C000301974

IMAGES
of England

BEDLINGTONSHIRE

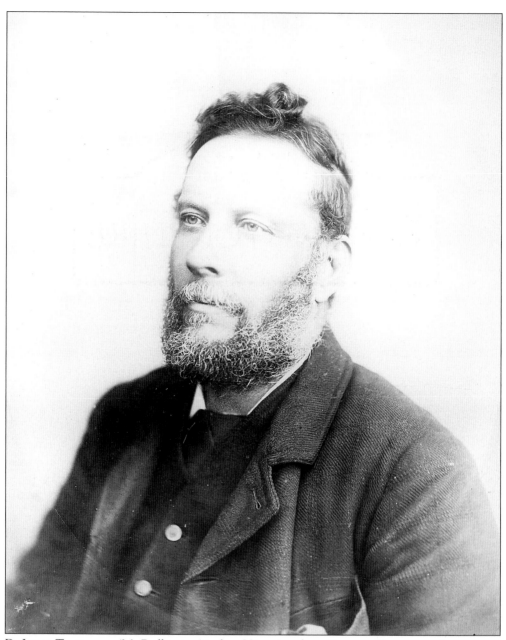

Dr James Trotter was 'Mr Bedlington' in late Victorian days. He was a Scotsman who came to the town in 1864 to join his brother as a GP. He died in 1899 and a memorial was erected by public subscription which has stood at the top of the town since the turn of the century. He worked diligently for the improvement of working class living conditions and was a poet and writer of some distinction. Dr Trotter is buried in Kells, Galloway.

IMAGES
of England

BEDLINGTONSHIRE

Compiled by
Evan Martin

TEMPUS

*This book is dedicated to the cherished memory
of our darling daughter Christine*

First published 1997
Reprinted 1999, 2004

Tempus Publishing Limited
The Mill, Brimscombe Port,
Stroud, Gloucestershire, GL5 2QG
www.tempus-publishing.com

© Evan Martin, 1997

The right of Evan Martin to be identified as the Author
of this work has been asserted in accordance with the
Copyrights, Designs and Patents Act 1988.

All rights reserved. No part of this book may be reprinted
or reproduced or utilised in any form or by any electronic,
mechanical or other means, now known or hereafter invented,
including photocopying and recording, or in any information
storage or retrieval system, without the permission in writing
from the Publishers.

British Library Cataloguing in Publication Data.
A catalogue record for this book is available from the British Library.

ISBN 0 7524 0784 8

Typesetting and origination by Tempus Publishing Limited.
Printed in Great Britain.

Contents

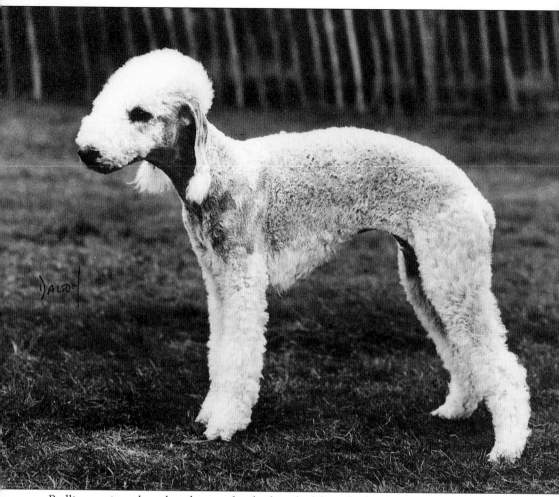

Bedlington is perhaps best known for the breed of dog which takes its name. The Bedlington Terrier is one of the most popular show dogs in the U.S.A. and the town is often visited by owners who photograph their dog(s) at one of the town's entrance signs. Originally bred in the early part of the nineteenth century (from 1820 by Vicar Cotes' two sons Ned and John), other breeders through Victorian times included some famous surnames in Bedlington's history. Joe Aynsley, Bob Hay, Jim Howe, Bob Fish, Tom Soulsby, Bill Hay, Tom Bell, Bob Steel and Ned Stoker were fanciers and breeders of times past. Perhaps the best known 'terrier man' of recent times was Neddie Metcalf of the Gardeners' Arms, who was 'the man to see about Bedlington Terriers', between the wars and just after. Pictured here is Champion bitch Dancer's Desire owned by Christine and Craig Richardson of Seghill. The National Bedlington Terrier Club was formed in 1898 and will hold its centenary meeting at Bedlingtonshire High School.

Introduction

Bedlingtonshire was part of the Palatine of Durham for over 900 years until it was annexed to Northumberland in 1844. When first purchased by the Bishop of Chester le Street around 910, it included Betlyntun and the hamlets of Nederton, Grubbe, Twisle, Cebbingtun, Sliceburn and Cammes. Bedlingtonshire crops up in history throughout the ages and we know that for hundreds of years the inhabitants relied, generally, on rural industries for their living. The year 1736 changed the face of the environment when ironworking, with its dirt and puddling furnaces, gave the area its first look at heavy industry. Coal mining followed a century later and completely changed the character of Bedlingtonshire, which played its part in the Industrial Revolution. Pits and ironworking meant jobs, and jobs meant an influx of men and their families, mainly from the Borders of Scotland, Ireland and East Anglia. Later the South West of England lost workers to this area but they all seemed to 'gel' and end up as Bedlington 'Terriers'.

Carr's newsagent's shop, for one example, saw the opportunity to have photographs taken of the area to sell in postcard form. It was pre telephone days and anyone in Bedlington wanting to pay an afternoon visit to a relation in, say, Choppington, could guarantee a postcard message arriving second post the same day from an early morning posting. Consequently, there are many photographs of any area of the pre First World War period and some of Bedlingtonshire are included in the 202 in this book. Photography has been a hobby and pastime, as well as a profession, for many people over the last hundred years. Fortunately many of the cameras and lenses used in bygone days were of better quality than some of their modern counterparts. This has resulted in many good family 'snaps' being of use in historical reference terms and examples are used in the book.

Many people from other parts of the country still wrongly regard Northumberland as being full of coal mines and shipyards. No Bedlingtonshire person, of thirty years or more experience, can deny there were days when coal smoke and 'muck' spoiled Monday's washing and lay on window ledges inside as well as outside houses. The closing of the mines in the 1960s and '70s has done much to rid us of those hazards. Today Bedlingtonshire is a much vaunted place in which to live. The mines have disappeared with only the odd tell tale sign to remind us of our heritage and fine housing estates have taken their place, so today's photographs of this old detached part of the County of Durham are obviously different in their topographical composition. History covers every facet of human experience and emotion, from tragedy through romance to comedy. This book has been compiled with this in mind and it is hoped it will go some way to satisfying the nostalgia in you. If you read the text, view the illustrations and are enlightened, then this is a bonus. If you are surprised, have the odd laugh and generally find some pleasure, then the author's aims and objects will have been realised.

Evan Martin
Bedlington
May 1997

Acknowledgements

I am indebted to Bob Parmley for his fine photographic work and to the following friends and associates who kindly allowed me to reproduce their photographs and gave valuable information: Ernest Appleby, Phoebe Barr, Betty Bower, Ann & Cuthbert Cochrane, Bill Cowans, Jack Dunsmore, Ethel Elliott, Malcolm Farquhar, Pauline Giacopazzi, Michael Goonan, Alan Johnson, Ron Johnson, Dixon Jordan, Ken Jordan, Jacqueline & Leo Molloy, Mary Murray, Father O'Connor, Margaret Oliver, Margaret Penny, Christine & Craig Richardson, Eric Ross, Peggy Smith, Keith Stewart, Ted Thompson, Elizabeth Wade. Steve Martin and Bill Nicholson were great local historians in Bedlingtonshire; their papers and reference notes have been of enormous help in compiling this book. I would also like to thank Andrew Clark, North East Editor of Chalford Publishing. Finally, the typing and proofreading was done by my wife, Judith Martin and this unenviable task was carried out with great diligence.

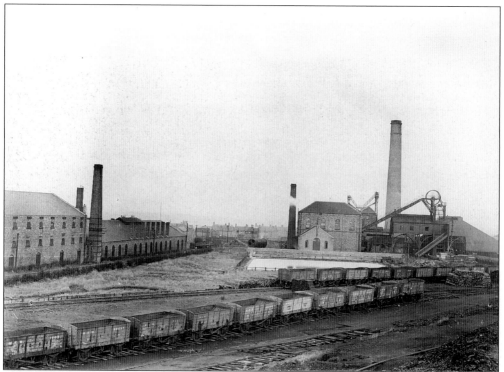

Coal mining and its attached 'screens' such as these dominated the horizons of Bedlingtonshire for well over one hundred years. This is the 'A' or 'Aad' Pit in 1905.

One
Bedlington Front Street

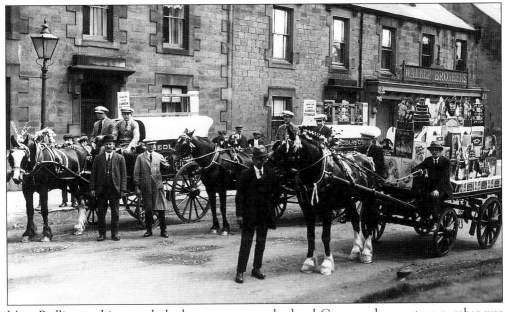

Most Bedlingtonshire people had an account at the local Co-op and your store number was never forgotten. Here the Co-op carts are displayed not far from the 'Bottom Store' down Front Street East.

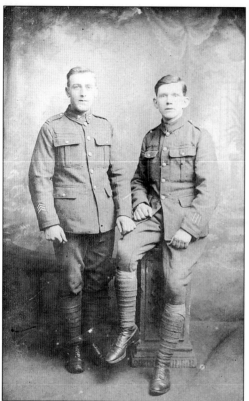

Many a pitman took up the army's offer of a trip to France and a shilling. Unfortunately many did not return. Of those who did, the experience left them shocked and often injured. These two lads, Private Bob Rainey of Doctor Terrace and Corporal Tom Mullarkey of North Terrace, were in the Tyneside Irish Regiment and returned home after hostilities ceased in 1918.

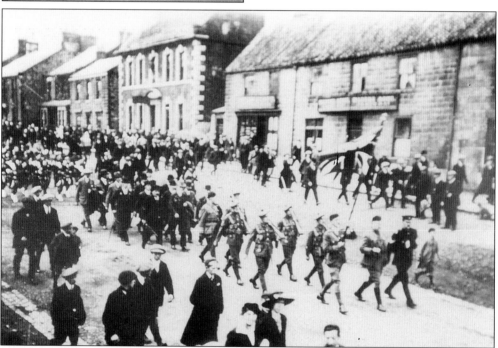

The procession leading to St Cuthbert's church prior to the resting of the colours of the Tyneside Scottish Regiment. Civic dignitaries, veterans and a highland pipe band took part.

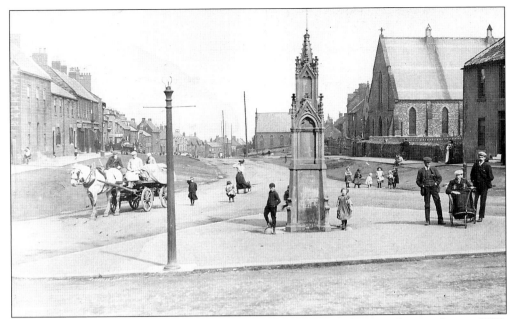

James Trotter's memorial hadn't been standing long when this photograph was taken in 1902, yet it had not escaped the attention of the vandals and graffiti merchants.

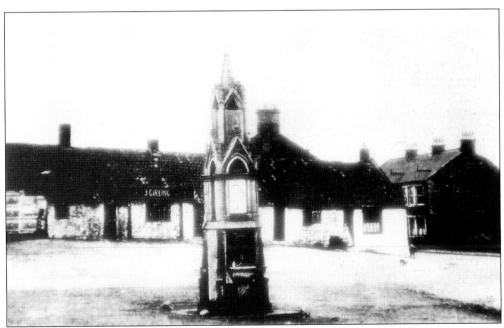

From the other side, the monument can clearly be seen as a fountain with Mr Girling's plumber's shop alongside the other properties north of the Red Lion.

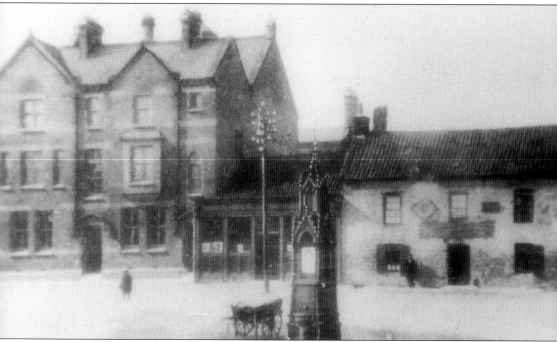

The large police station and courthouse is still a prominent feature of Bedlington's Top End, but the Red Lion has undergone many changes from the property shown here. The Red Lion, in its Victorian days, was regarded as a den of iniquity by many God fearing citizens and some mothers warned their daughters to walk around the monument when passing from north to south (or vice versa) crossing the top of the town. The police station, erected in 1894, was replaced in 1998 by a new building on the site of the Doctor Pit.

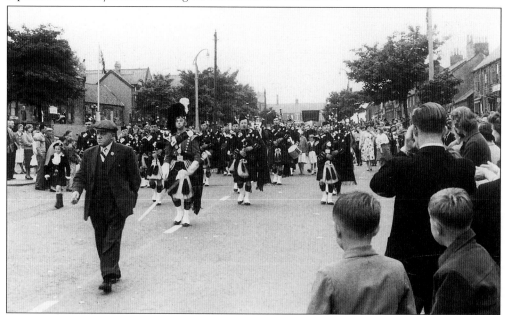

The procession for Miners' Picnic Day in 1959. The picnic was always the first Saturday in June.

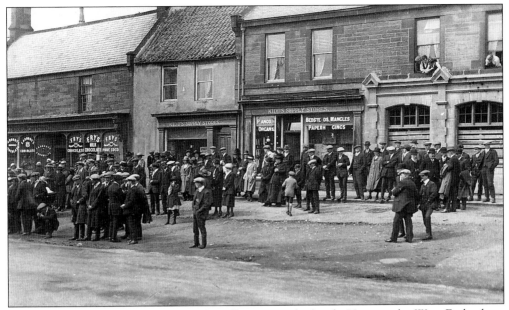

The visits of celebrities always proved a talking point for locals. Here, at the West End, where the main bus stop is now, a large group gathers to greet Earl Grey. Kidd's Supply Stores and Thornton's Confectioners, provide the background.

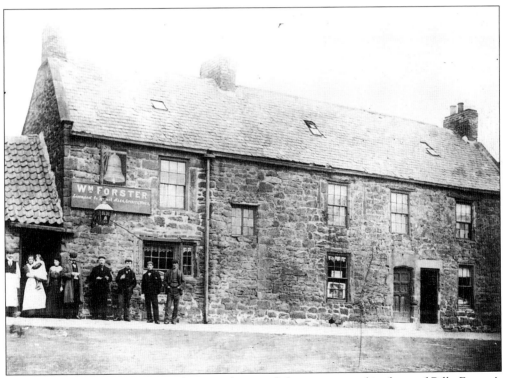

News got round that a photographer was about and this group posed in front of Billy Forster's Blue Bell Inn in 1901. Next door was Mrs Brown's 'peace offering' sweet shop. The pub was converted to its present state shortly after this photograph was taken.

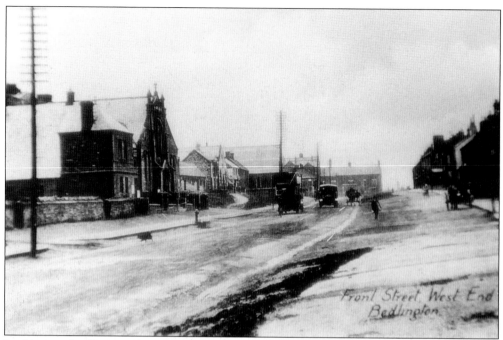

Looking up the Street in the mid 1920s before the hard rock on the side was dug out, soil put in and trees planted. Charlie Balmbro's open top coach can be seen shuddering its way to 'The Top End'.

A peaceful Front Street in the early 1940s.

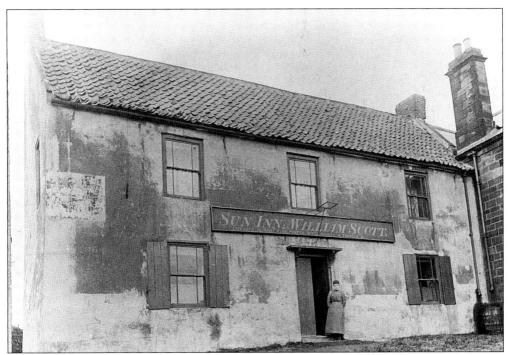

Meggie Morris stands at the door of the old Sun Inn in late Victorian times.

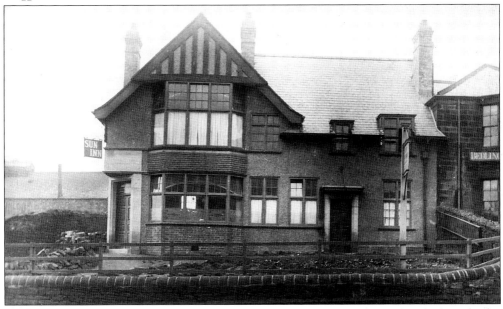

Before the start of the First World War, the Sun Inn had been completely rebuilt and John (Jocker) Amos was installed as manager. His behaviour on the afternoon of 15 April 1913, was to put Bedlington on the front of all the national newspapers. Accused by John Irons, the owner, of being nearly £46 light at the till, Amos was ordered to make good the loss or forfeit his £30 bond, held by Irons, and lose his job. Amos went berserk and in the course of the afternoon shot the new, would be tenant's wife, Mrs Grice and local policemen Sgt Andrew Barton and PC George Mussell. Amos was arrested, tried, and hanged in Newcastle Gaol on 22 July 1913.

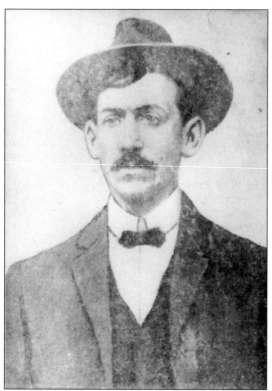

John Vickers Amos, aged 35, who despite his terrible acts received a lot of public support after his arrest and 60,000 people signed a petition in his support.

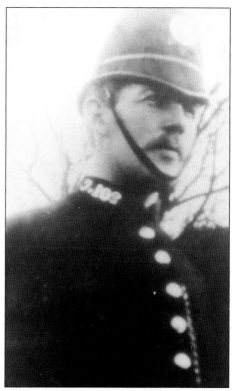

Sgt Andrew Barton, who had received awards for bravery, was shot twice in the stomach by Amos.

The other police victim of Amos' madness was PC George Mussell. Mussell was standing in for a colleague that fateful afternoon.

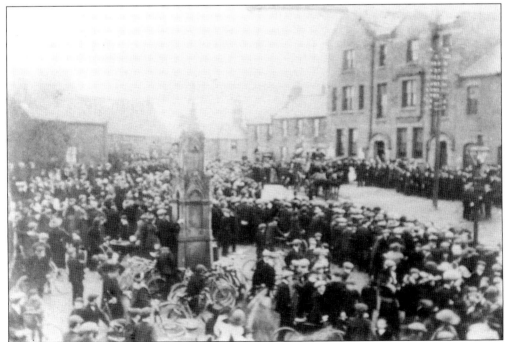

The funeral procession for the policemen, passes the police station.

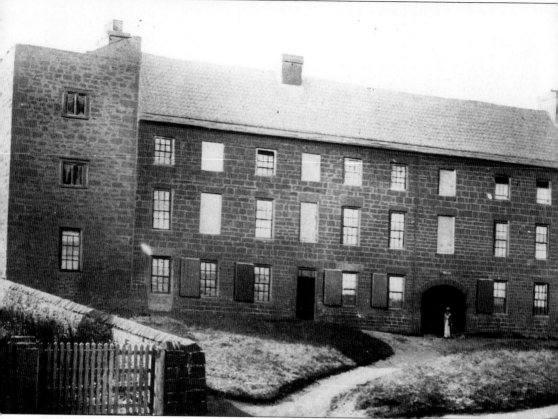

The Norman pele tower, on the left of the picture, together with an adjoining fourteenth century manor house made up what Bedlingtonians knew as The Old Hall. This was pulled down in the late 1950s to make way for the Council Offices of Bedlingtonshire Urban District Council. With Bedlingtonshire being under the jurisdiction of the Bishop of Durham for hundreds of years, a bailiff was always in residence here, certainly from as early as 1379 until the last appointment in 1746. When in 1844 the Bishop handed over control of the Shire, the Hall became vacant and was leased in 1846 to James Longridge of Barrington Colliery for the housing of his miners. Bedlington Coal Company took over the lease in 1858 and the Hall was inhabited until one hundred years after this date when demolition started. This photograph was taken by Tom Taylor in 1910.

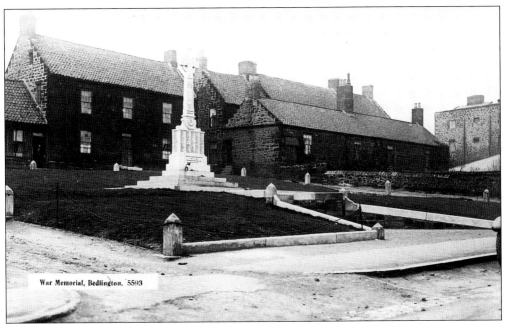

War Memorial, Bedlington. 5593

The War Memorial is a feature of Front Street. In many towns the cenotaph is hidden away in some forgotten corner. Not so in Bedlington where it graces land in the centre of town. The Quarry Cottages have long since gone and occupy the site of the two large houses which now skirt the road into Windsor Gardens.

The old market in full swing in late Victorian days. The Co-operative societies killed off the markets. Miners' wives would rather shop at the Co-op and reap the benefit of a cash dividend, as shop at the market stalls. For example, Bedlington Co-op paid a dividend of 3s 5½d in the pound in 1891.

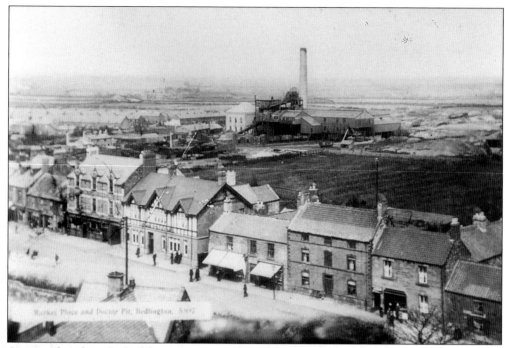

A view taken from St Cuthbert's tower in 1932. This sums up what Bedlington was at the time, a busy little town dominated by the colliery. This and a selection of other scenes from Bedlingtonshire villages were taken for the Danish butter producers who sold their dairy products to Bedlington Co-op. In return the Danes bought our coal.

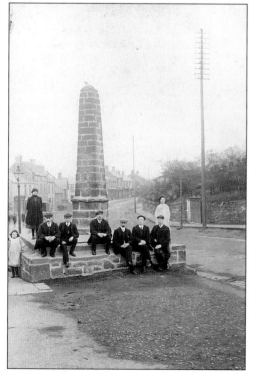

On the ground in the market place miners pose on a Sunday morning, in their 'Sunday Best', c. 1906. Jim Jefferson is seated second from the right. Always a favourite meeting place in the past, the Cross was nicknamed 'The Nail', obviously due to its shape and the fact that dealers paid 'on the nail' on market days.

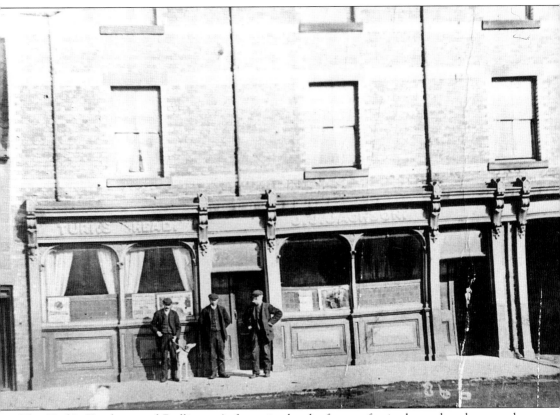

The Turk's Head, one of Bedlington's favourite locals, famous for its beer, dog shows and collection of characters. Dr Trotter was a regular patron in Victorian times as was his great friend, watchmaker, Jimmy Freeman. When Jimmy died in 1897 Dr Trotter composed a poem as an epitaph to a great Bedlington celebrity:

Here Jimmy Freeman's clock case lies
His works now tick beyond the skies
The key that wound him up is lost
Or in the pocket of his ghost
Ye Grubs that on his carcase feast
You're sucking nowt but brewer's yeast
Ye worms that drink his blood and grin
You're mortal drunk with Turk's Head gin.

The Turk's Head site is now occupied by Kwik Save.

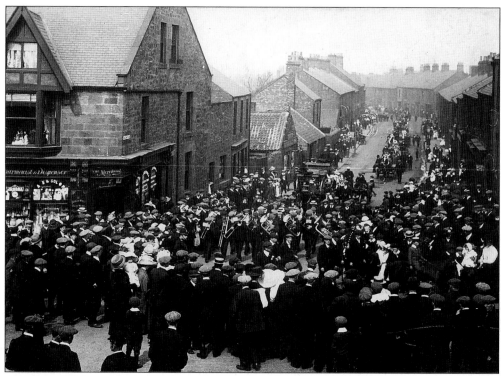

A regular Whitsuntide occasion, with Netherton Colliery Band leading the procession of decorated business carts up Vulcan Place.

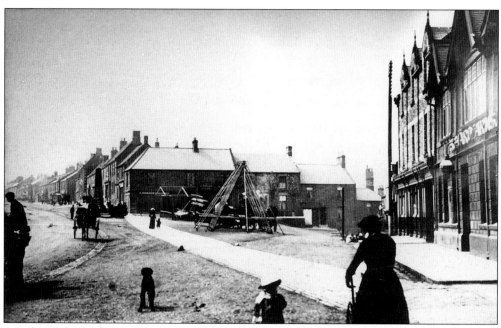

Another Whit picture, with the market area taken over by swings and sideshows. This view shows the new cobbled footpath in place from the Howard Arms to Andrew Fairbairn's shop and dates the scene as around 1902.

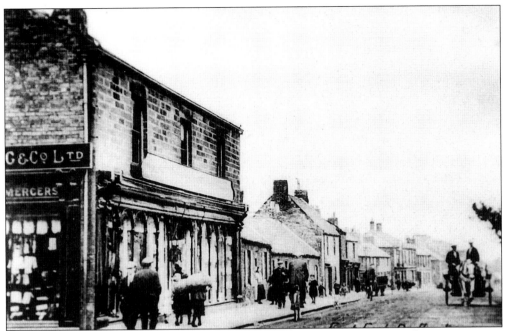

The structure of the East End hasn't changed a great deal and many of the buildings retain their charm. Many families were prominent in Bedlington businesses over the years. None more so than the Foggans. Here Foggan, the dairyman, is seen driving his horse and milk float up the street towards Hedley's shop.

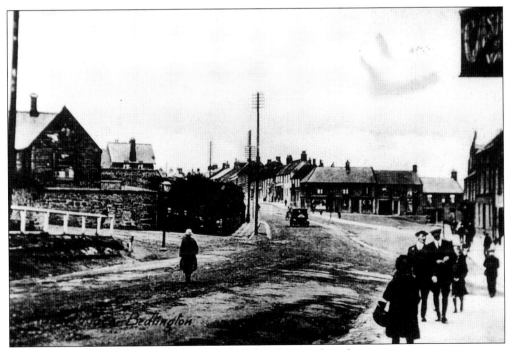

An early 1920s panoramic view showing the 'clarty' streets but clean pavements.

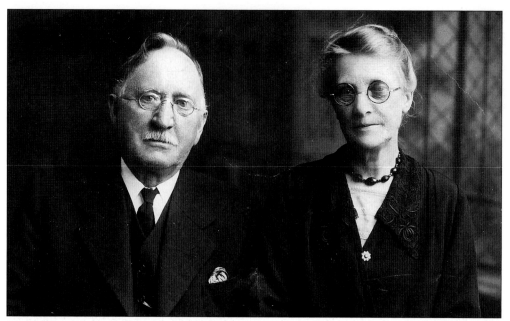

Mr and Mrs Hemsted from the well known Bedlington family.

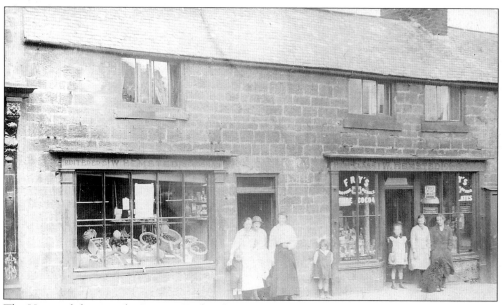

The Hemsted shops at the Bottom End with May Farrington, Mrs Hemsted, Peg Hemsted, Lucy Slaughter and Phoebe Jefferson.

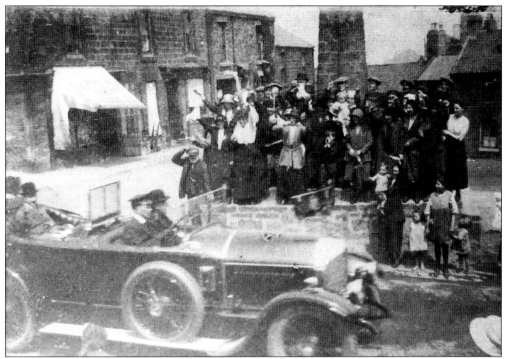

The Cross again in use, this time as a vantage point. The Prince of Wales, later Edward VIII, visited the area in the late 1920s. He went down the colliery rows, spoke to residents and then was driven down Front Street.

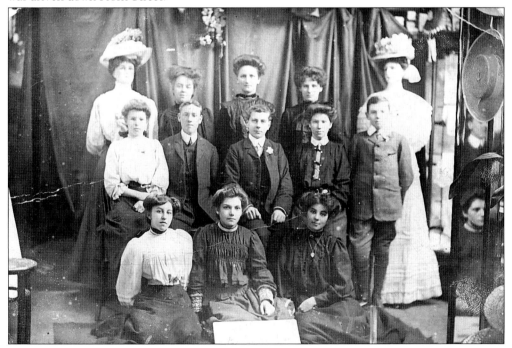

Feasters was a well known drapers on Front Street East. This photograph of the staff and models was taken for an exhibition held in the shop in 1908.

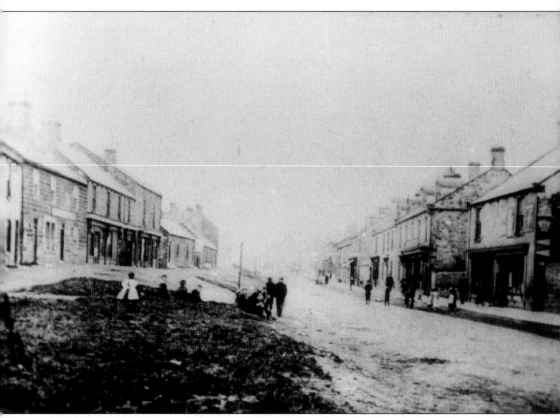

A rather desolate picture of the Bottom End. This is almost half a mile from the top of the town and the Red Lion. This photograph, taken in the 1890s, shows the original 'bottom store' building on the left. The property on the same side is now part of Millfield Court. Some of the oldest and most pleasing architectural buildings in Bedlington are on the right and still stand today, although their purpose has obviously changed.

Two
Around Bedlington, Netherton and Hartford Bridge

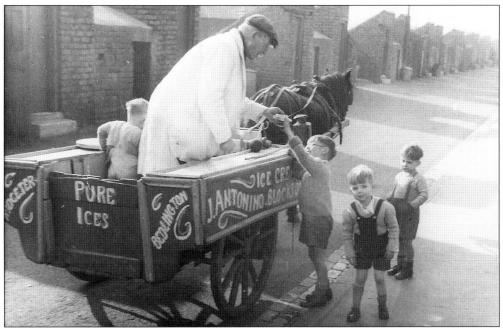

Nobody was seen more, or was more popular around Bedlington, than Jack Antoniho. His factory was at the back of Ridge Terrace where he lived. Jack traded around Bedlington streets for sixty years and his ice cream was delicious.

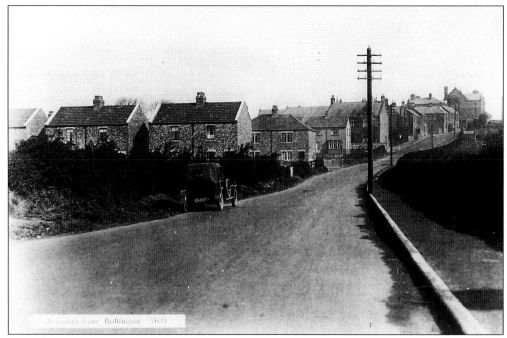

Hartford Road, the Southward route out of Bedlington, as it was in 1924. Hartford Crescent had recently been built but Centenary Cottages had another fourteen years to go and Hartlands was a long way off.

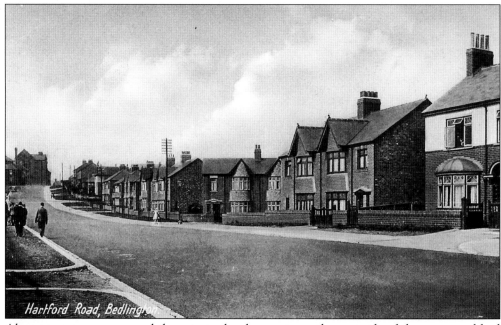

Almost twenty years on and the private developments on the east side of the same road had gathered apace. Fifty years later it has changed very little.

A.D. 1801

Steady the path ordain'd by nature's God,
And free from human vices, Wheatley trod
Yet hop'd no future life - his all he liv'd -
The turf he grazed his parting breath received
And now protect his bones; disturb them not
But let one faithful horse respected rot.

Revd Henry Cotes BA was Vicar of St Cuthbert's from 1788-1835 and by all accounts was something of a character. This is the 'tombstone' he erected to the memory of his horse Wheatley and placed in the wall in the church paddock. There was an enemy of Cotes, however, by the name of James Waddell, a poet, dubbed 'The Plessey Bard', who believed Cotes shot the horse, as there was a tax levied on horse keeping at the time and the cost of hay had gone up. Waddell wrote:

… You shot him solely to avoid the tax,
Another reason too, as many say,
Dear was the corn but dearer was the hay …

The stone still exists in a garden in the Towers Close area. One reason perhaps for Waddell's obvious animosity was that Vicar Cotes was regarded as far superior, in the writing of prose and poetry, to Waddell. Many of Cotes' literary efforts may be seen in the British Museum.

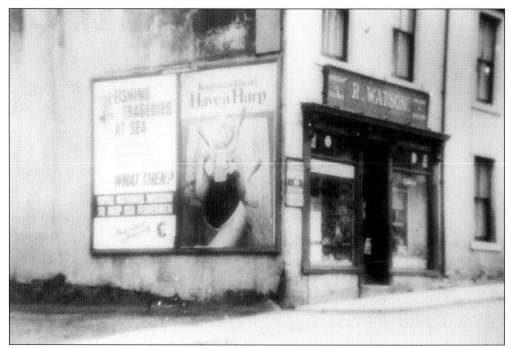

Down the Glebe Row bank, as it was before the coming of the dual carriageway and the roundabout in 1971. Bob Watson, his daughter Winnie and son Raymond ran this newsagents business for many years before moving to Front Street. The property had previously belonged to the Co-op.

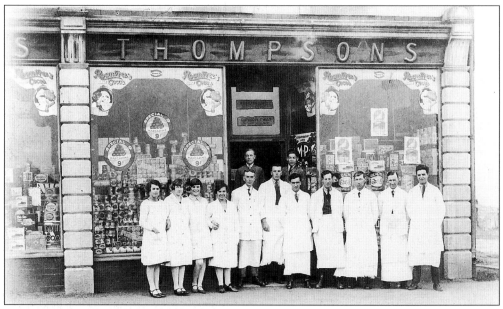

The staff at Thompson's Stores down Glebe Row in 1925. An added incentive to buy there was the Red Stamp gift scheme, which was serious competition to the Co-op dividend. The site is now occupied by Kelda Car Sales.

Looking down Glebe Road from the Wharton Arms corner in the late 1940s. The Food Office on the right had been the Alma Inn. Other pubs down this street were the Tankerville Arms and the Fountain Inn. The dual carriageway takes up all this land now.

From the time the pits opened in the middle of the nineteenth century, strikes and 'layings off' were commonplace. Soup kitchen workers like these during 1921 were a welcome sight. They are: Joe Elliot, Sally and Bill Neave, Sally Sanderson, Dave and Mrs Richardson, Mrs Hobson, Mrs Arkle and Ted Short. All were from the Dr Pit rows.

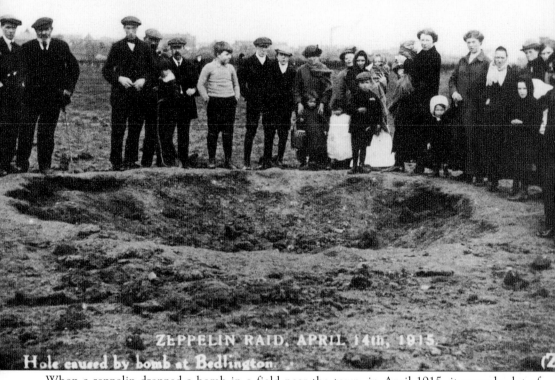

ZEPPELIN RAID, APRIL 14th, 1915.
Hole caused by bomb at Bedlington.

When a zeppelin dropped a bomb in a field near the town, in April 1915, it caused a lot of interest. But where was 'the hole'? Some would have it at Hirst Head Farm, others the Twenty Acres. How about where Hartlands is now? Perhaps the pit chimney and buildings behind could give a clue. This photograph is dated 14 April 1915 but there are others dated a day earlier. John Wade, who left Hirst Head Farm in 1997, firmly believes that the bomb dropped on a farm field in his grandfather's time. He insists the shape of the crater remained there as proof until houses were built on the site in 1998. Local newspapers carried the story of the zeppelin's visit, suggesting that the operation was meant to bomb the ironworks at Bedlington. Apparently no-one had told the Kaiser that the ironworks had closed forty-eight years earlier. Such was the interest in this 'invasion' that almost everyone wanted a souvenir. As far as it is known no-one actually took a photograph of the zeppelin over the area, but there are many 'phonies' with zeppelins stuck on to photographs of Bedlington, Guide Post, Blyth and Newbiggin. They sold very well and are commonplace in family albums in the area.

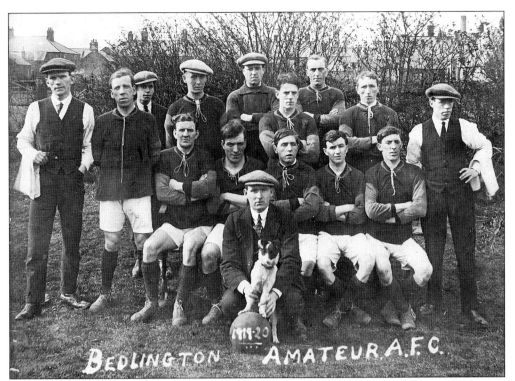

Down at the East End a popular meeting place for sportsmen was Price's Field at Hollymount. This Bedlington Amateur side of 1920 was only one of many that called this area its headquarters.

A rare photograph of Pit Row prior to the building of Hollymount Square. In the photograph are Mr and Mrs Bill Hemsted, their daughter Phoebe and her son Bernard.

The dismantling of 'The Milk House', behind Front Street East, prior to the building of Millfield Court. Although it was used as a dairy, these oast ovens give evidence of the fact that this was one of two breweries Bedlington had in the eighteenth and nineteenth centuries. The other was behind Brewery House (Northern Rock).

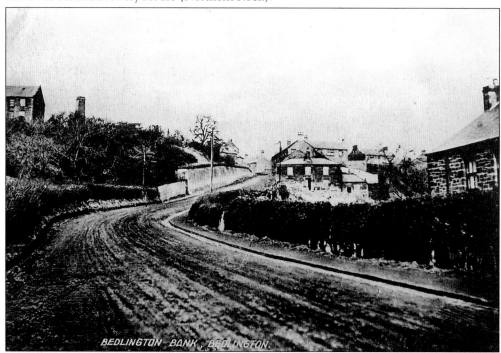

BEDLINGTON BANK, BEDLINGTON.

Bedlington is reached by an incline whichever way you enter it; probably the reason the Saxons thought it a good fortress. This is the Eastern approach just beyond the River Blyth with The Quay, on the right, and Petrie's corn mill and chimney on the left.

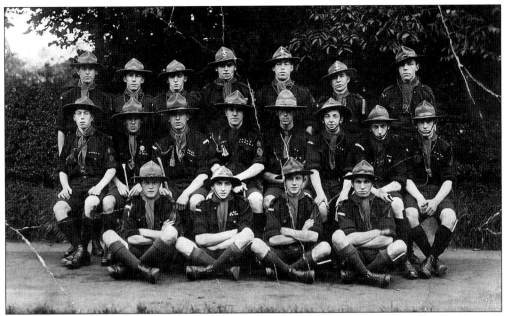

Willie Hall, Bedlingtonshire UDC surveyor and engineer, with his scout troop in the early 1920s.

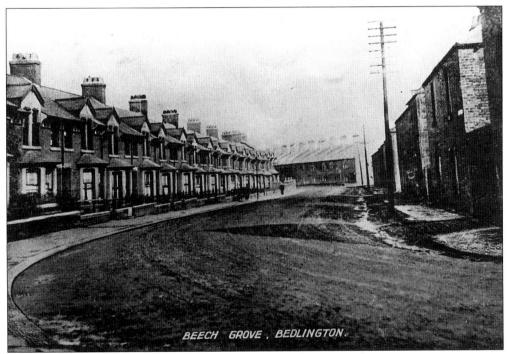

Beech Grove, on the left, at one time had Mr Foreman's theatre on the south end of it. The Swann family built Hirst Terrace North opposite and in 1872 Stoker's Buildings were completed. The final touches were put to Vulcan Place School in 1896 and it was renamed Whitley Memorial after Canon Whitley who died the year before.

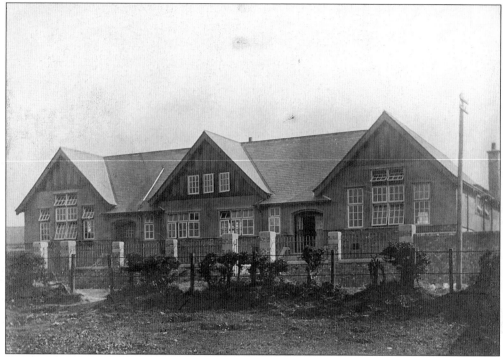

Bedlington Council School, Junior Department was opened on 15 June 1908 and the Infant Department five years later. This photograph was taken shortly after this Junior building was opened.

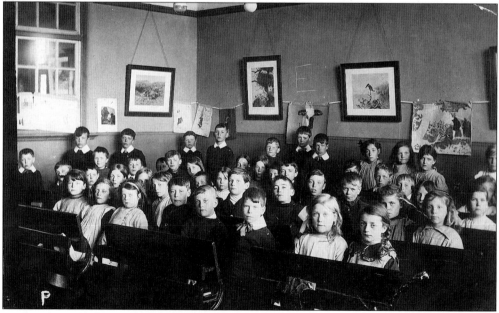

A class from Bedlington Council School in 1914. Included are: Grace Richardson, Lizzie Green, Arthur Smith, Joe Legget, Alice Neave, Margaret Elliot. Second row: Lily Sanderson, Margaret Douglas, Sid Maddison, Alec Barnes. Others include Lizzie Legget, Lydia Armstrong, Mary Cooper, Harry Orange, Tom and Netta Bailey, Ken Turnbull, Jimmy Millne.

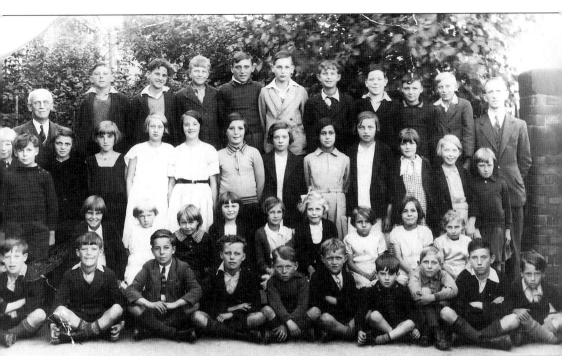

Joe Thompson, far left in the back row, was a noted disciplinarian and always wore a bowler hat to school to show who was boss. He retired from Bedlington Council School in 1937 to be followed by Ernie Wood who held the headteacher's post for twenty-two years, then Henry Graham took over. Alan Smart, the young class teacher pictured here, furthered his career as art master under Gilbert Richards at Bedlington Grammar School, then went on to be head of Guide Post Secondary School, before retiring. This photograph, taken around 1935, includes the Moscrop twins, Edna and Fenwick. Fenwick later became a well known mine host at the King's Arms and Bedlingtonshire Golf Club. Also pictured are Councillor to be Joe Miller, and Ken, Charlie and Fred Dott. This school was a noted breeding ground for headteachers. Apart from Alan Smart, other young teachers who went on to become headteachers in Northumberland in 1960 include; Vera Piercy, John Wharrier, Evan Martin, John Gray, Ian Nelson and Bob Rogers.

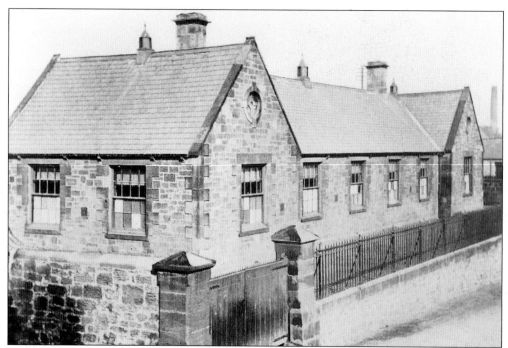

The Village Infant School, 1910. Variably named Whitley Infants or Church Infants, it opened in May 1874. It is now known as the Village, or Church, Hall.

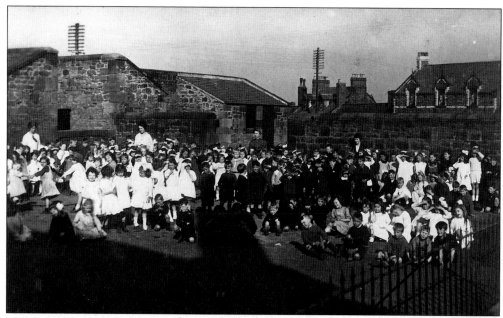

The date of this photograph is unknown, although the period looks like the 1930s. It shows the cramped school yard of the Church Infant's School on a special occasion (most of the girls are in their best dresses). The children from this school 'fed' Whitley Memorial School.

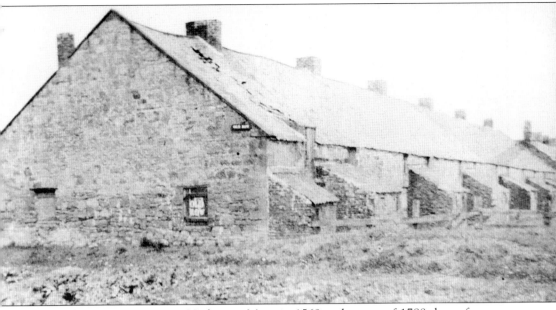

There is reference to a mine on Netherton Moor in 1569 and a map of 1788 shows fourteen shafts in and around the village. These shafts were dug to a depth of one hundred feet. In 1829 a new pit was opened and called The Railway Pit. Soon after this, back to back workmen's cottages, pictured here, were built. These became known as 'Old Row', or 'Aad Raa', when later properties were erected. It is not known when this street was demolished but early Edwardian times would not be far out, as the 'new' Netherton Colliery houses, First, Second, Plessey and Third Streets were commenced in September 1905 giving 152 houses for the village miners.

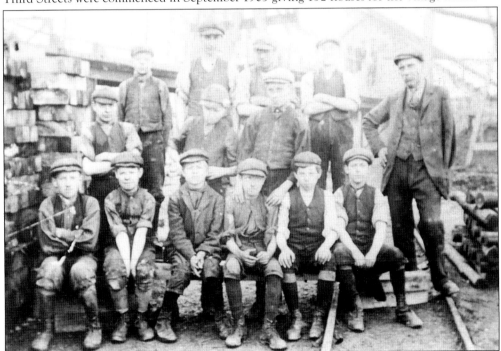

Netherton Howard Pit surface lads with their one armed heapmaster gaffer.

The front of Howard House, originally built for the viewer of Netherton Colliery.

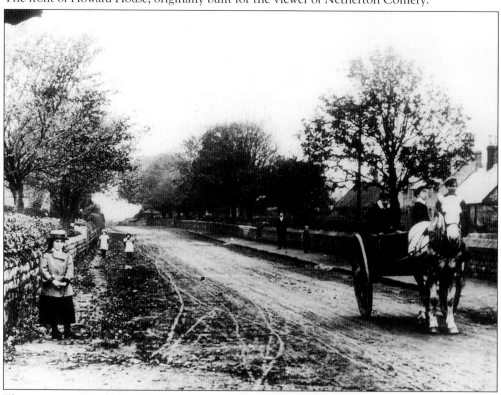

The serenity of Nedderton Village can be felt looking at this 1903 print. Not far from here is the village school provided in 1846 by the landowner, Lord Carlisle.

COALS.

Netherton and Morpeth
RAIL-WAY
COMPANY

RESPECTFULLY beg leave to inform the Public that they have now completed their

STAITH OR DEPOT
AT
MORPETH,

AND WILL COMMENCE SELLING

NETHERTON COALS,
On Monday the 13th Instant,

At the said STAITH or DEPOT at the following Prices, viz :—
at 6d. Per BOLL, or 4s. Per FOTHER, and at the COLLIERY
at 5d. Per BOLL, or 3s. 4d. Per FOTHER.

Netherton Colliery Office, Sept. 11. 1830.

C· ton, Printer, Market-Place, Morp·th.

5

The Netherton to Morpeth Railway was laid to Stobhill with Bedlington Ironworks' malleable iron rails. This poster was proudly displayed to advertise the sale of Netherton coals.

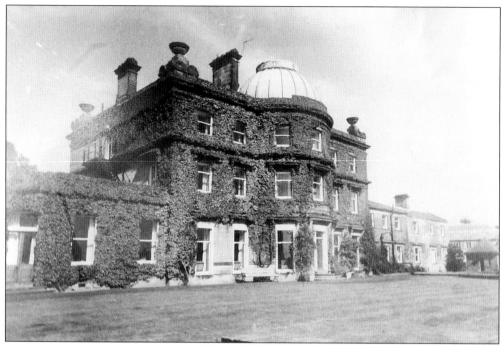

A front view of Hartford Hall, once the home of the Burdon family then later the Thompsons of Red Stamp Stores fame. Built in the early 1800s, and further developed in 1872, it stands majestically on the banks of the River Blyth.

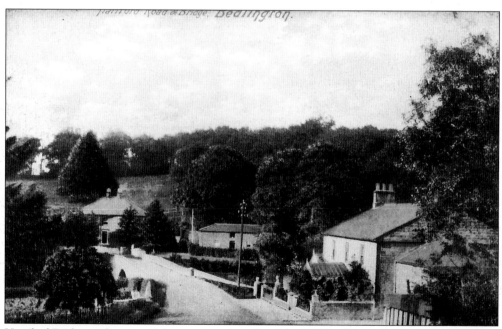

Hartford Bridge at the turn of the century. A study of the 1859 ordinance survey map shows the Jolly Anglers Inn to the north of the bridge. On the south side was the Hartford Bridge Inn.

Three
Choppington Township

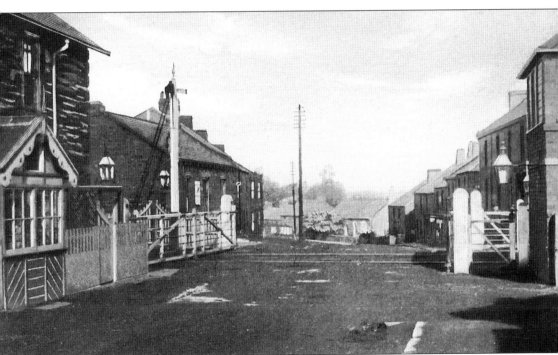

Choppington Station in 1910. At this time it was a busy little community with a flourishing rail trade in both goods and passengers. The railway opened to the public in July 1858, with trains stopping in the middle of the road. As business developed the line was doubled and the platform extended.

Barbara Wade, right, with her friend Isabella Ritchie, at the back of the Lord Clyde in 1918. Barbara was well known in Choppington. Her grandmother, Mrs Hall, ran the Lord Clyde for many years and it remained in the family for over 100 years. When pitmen were paid fortnightly, Barbara's grandmother would sit in the entrance to the pub on non payment (baff) week and give a half-crown loan to hard-up drinkers.

Barbara's son John was also a well known Choppington character. His six feet eight inch frame filled the bar, which was famous for its arrangement of rare lamps.

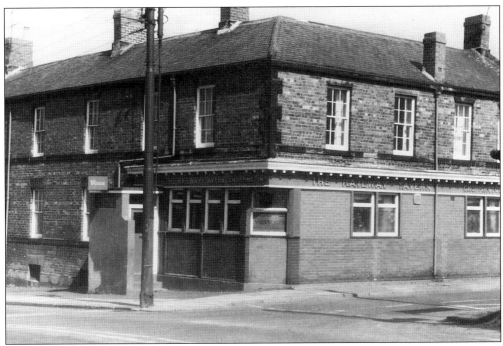

Two public houses sat next to the railway at Choppington Station. Both served mainly Choppington, Barrington and Netherton Colliery drinkers for well over a century. Here, the Railway Tavern, which stood at the west entrance to Barrington and is now demolished, was built in 1860.

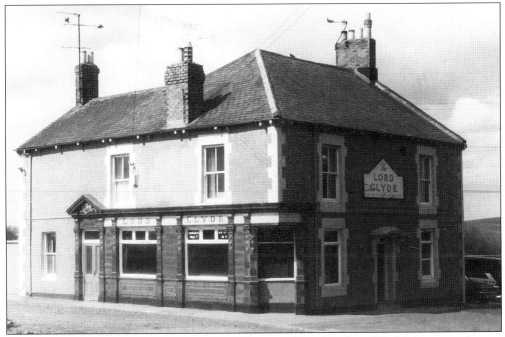

The Lord Clyde was famous for its beautiful tiles outside and Barbara Wade's home made soup and pies inside. It is now revamped and renamed 'The Swan'.

The German House (better known locally as 'The Jarmin Hoos'). This was built to a German design in 1869 for brickyard owner John Burns. On each side of the main doorway to the house was a set of cannon. Burns brickyard at its peak employed sixty people producing more than a million bricks and tiles per annum. Burns built twenty cottages on the south side of the railway. This was always known in the area as 'Burns' Raa'.

This photograph shows the original Sunniside, built before Burns' time, in 1826. The buildings provided offices for the Barrington Coal Company and in 1841 were converted into miners' homes. They were demolished in 1940.

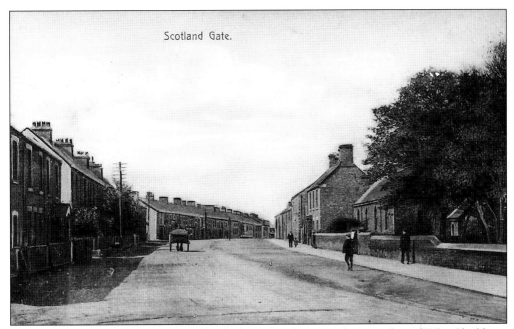

Scotland Gate.

Scotland Gate, here in 1910, is actually the boundary between the township of West Sleekburn on the east side and Bedlington, Glebe and Choppington on the west side. At the far right is the Church School, opened in 1872 and closed in 1945.

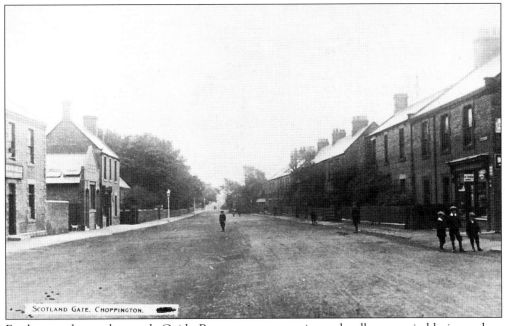

SCOTLAND GATE. CHOPPINGTON.

Further up the road towards Guide Post was a serene picture hardly recognisable in modern times. Choppington township had a census count of 128 in 1801. By 1911 this had risen to 5,432.

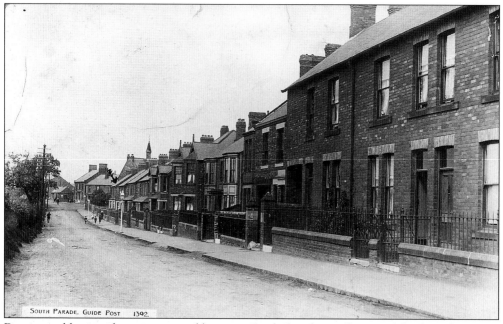

South Parade, Guide Post 1392.

Despite problems with sanitation and housing, Guide Post boasted some of the finest houses in the Shire. The dwellings on South Parade were much sought after properties by professional and business people .

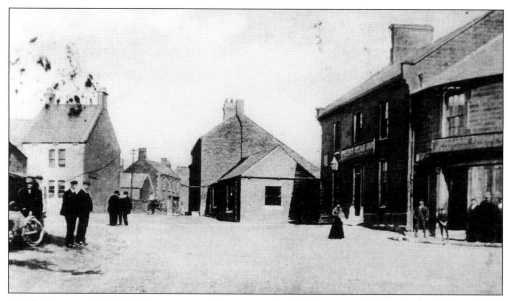

Guide Post, c. 1900. It bears no resemblance to the bustling roundabout area of almost 100 years later. The Anvil Inn, on the left, had a busy blacksmith's shop adjacent to it. A visitor to Guide Post in April 1873 wrote in the Newcastle Chronicle: 'We have heard so much about the sanitary state of the Guide Post that we approach it with apprehension, wearing boots and leggings'.

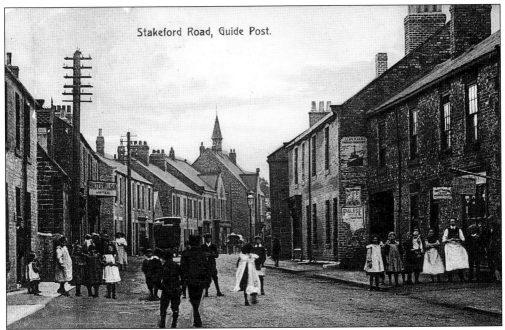

Epworth House with the bell tower, originally the Liberal Club, gives some idea of this location. This Edwardian photograph shows only half of the buildings we would know today.

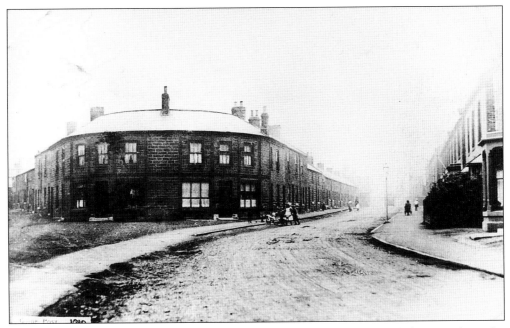

Edwardian times were popular for photographers. Another view of Guide Post, from the Shakespeare Tavern, taken in 1910.

CHOPPINGTON · CHURCH MAGAZINE.

DECEMBER, 1930.
PRICE TWOPENCE.

THIS IS YOUR SPIRITUAL HOME.
DON'T BE A LODGER.

Clergy—Rev. H. C. SNOWDEN, L.Th., Hon.C.F.
Rev. F. E. CHURCHYARD.

SERVICES, ETC.—

SUNDAYS—8 a.m., 10-30 a.m., 6 p.m.

HOLY COMMUNION—Every Sunday 8 a.m. 1st, 3rd, 5th, 10-30 a.m.

HOLY BAPTISMS—Sundays 3-30 p.m.— Notice to be given.

BIBLE CLASSES—2 p.m. in Church.

SUNDAY SCHOOLS, 2 p.m.

MOTHERS' UNION SERVICE, 1st Monday of month at 7 p.m., except June, July, August and September.

C.E.M.S., 1st Thursday of month, 7 p.m.

Churchwardens—Mr. J. C. Allison and Mr. J. C. Short.

Sidesmen—Dr. B. B. Noble, Messrs. G. Adamson, J. Barnfather, C. Berkley, E. Bond, T. Brodie, A. E. Cripps, T. Graham, A. Green, J. T. Leach. A. Rowe, E. Ternent.

Assistant Sidesmen—R. Chapman, E. Henry, W. Renwick, R. Wilkinson.

Organist—Mr. J. Hedley.

Deputy Organist—Mr. A. Green.

The Clergy would always be pleased to be informed of anyone desirous of seeing them.

St Paul's church, Choppington was consecrated in 1866. Built through public subscriptions, the cost was £1,900. The vicarage, built a year later, cost £1,600. Many old Choppington 'worthies' are named on the front of this church magazine from 1930.

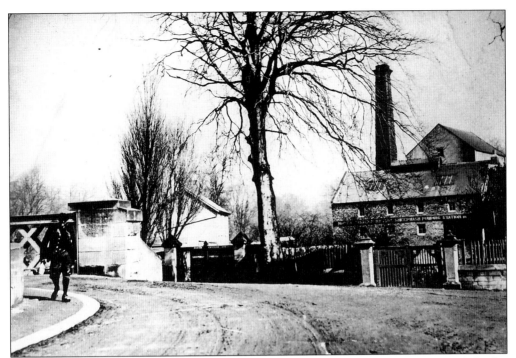

The entrance to Sheepwash bridge before the days of traffic lights. There is evidence of a bridge here in 1735 and it is possible this was the structure partly washed away in the floods of 1894. The North Eastern Railway pumping station, pictured with chimney and still standing today, is most probably the old manor house which belonged to John Middleton.

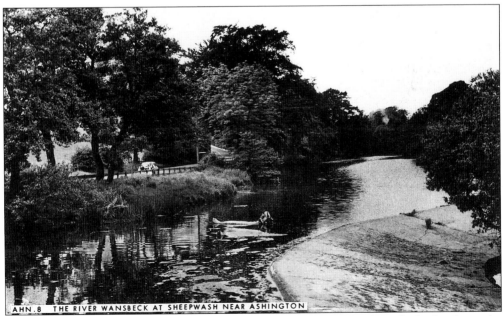

AHN.8 THE RIVER WANSBECK AT SHEEPWASH NEAR ASHINGTON

Sheepwash is an area which has always drawn day trippers. This view from the bridge shows the weir and the site of the old ford which went diagonally across the water from the bend shown at the bottom of Sheepwash bank to the turn on the Ashington side behind Glebe Farm.

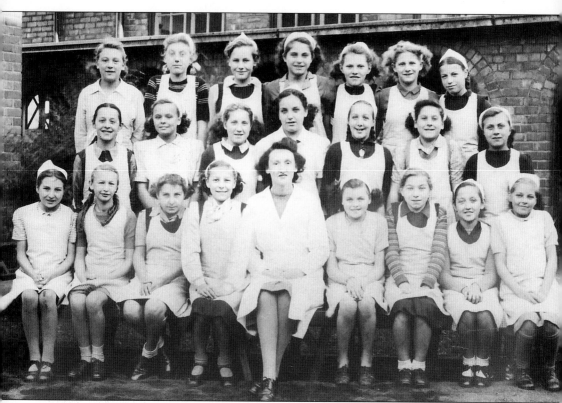

Guide Post Secondary School was built in 1906. Here is Form 2A's Domestic Science group in 1948. Back Row: L. Winn, J. Brown, J. Smith, M. Hall, B. Johnson, M. Crackett, N. Staton. Middle Row: M. Arris, F. Darling, B. McCallum, H. Wilkinson, S. Jenkinson, D. Million, M. Beal. Front Row: J. Simm, H. Davison, J. Alder, A. Redpath, Miss McDougal, M. Wright, S. Dobie, N. Armstrong, M. Martin.

Four

'Barnton, Bomar, The Ford and Reed Raa'

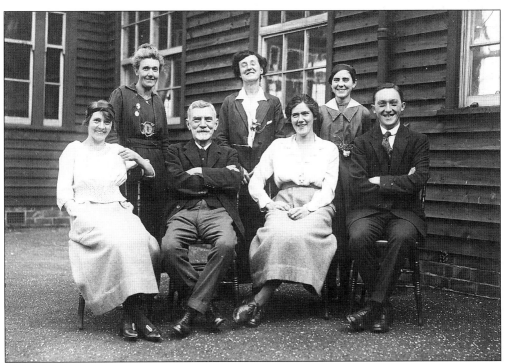

When the new school was opened in Barrington in 1913, no one was more pleased than headmaster Ben Berkley, picture here in 1920 with his staff, with Jim Wood on the right. Berkley had taken up the job at Barrington in 1878 when he was twenty-one years old and stayed forty-four years. He lived in the school house until 1905 when he and his family moved to Willowbridge, where he died in 1932.

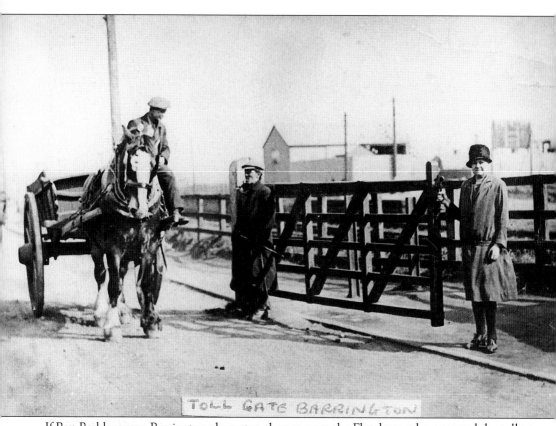

TOLL GATE BARRINGTON

If Ben Berkley was a Barrington character, then so were the Fletchers, who operated the tollgate at the Choppington end of the Barrington road. From here to the Primitive Methodist Chapel was coal company land, and from there to Sleekburn it belonged to Lord Barrington. The road was in good order and as a toll was acceptable, the coal company imposed charges from around 1869 until 1930 when the local council took over. The Fletchers were on call day and night but never failed to carry out their duties on behalf of the coal company. Levies in later days were fourpence for four wheels, twopence for two wheels, a penny for a horse or cow and a farthing for a sheep. Local newspapers of 1884 relate the story of Dr Carmichael who refused to pay his toll when on call to Barrington one dark night. He was alleged to have hit Mrs Fletcher with his crop and was taken to court by the coal company and fined for assault. Carmichael later used his power as Medical Officer of Health to condemn some of the company's houses, so gaining revenge.

Barrington's Railway Row, originally known as Low Railway Row, was built in 1865. There were eighteen houses which consisted of one downstairs room and one upstairs garret, with ladder. Eventually these were improved to two upstairs bedrooms reached by a staircase. Railway Row was demolished in May 1960.

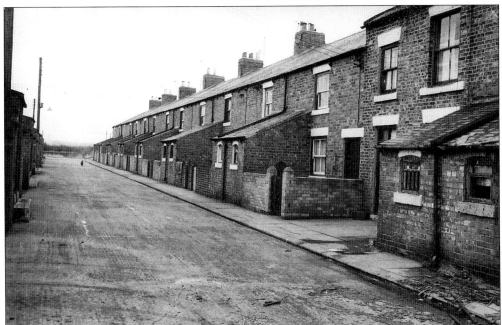

Office Row was regarded as better class housing when the seventeen houses were erected in 1899-90. Brick built, they had a living room, parlour and two upstairs bedrooms. This row, together with Victoria and Alexandra rows, lasted the longest, being pulled down in 1969.

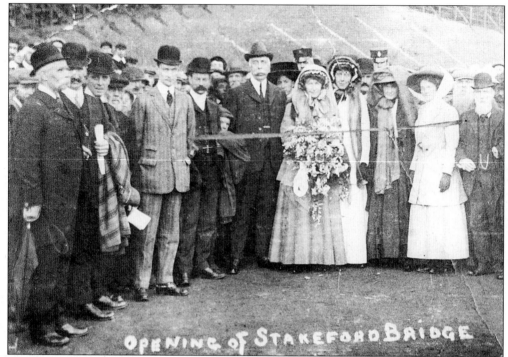

OPENING OF STAKEFORD BRIDGE

The way north out of Bedlingtonshire was made easier when Stakeford Bridge was opened on 11 September 1909. Here, Francis Priestman of the Ashington Coal Company, his daughters and local civic dignitaries attend the opening ceremony.

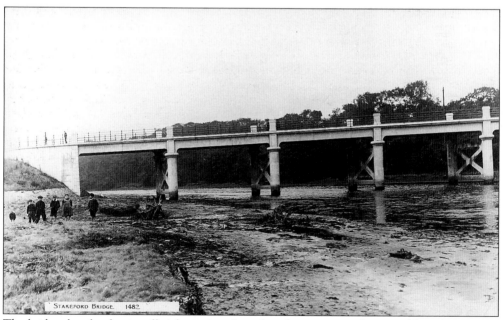

STAKEFORD BRIDGE. 1482.

The bridge shortly after its official opening. It took eight years to gather in public subscriptions to cover the cost of the development. The money was mainly donated by Ashington and Bedlington Coal Companies.

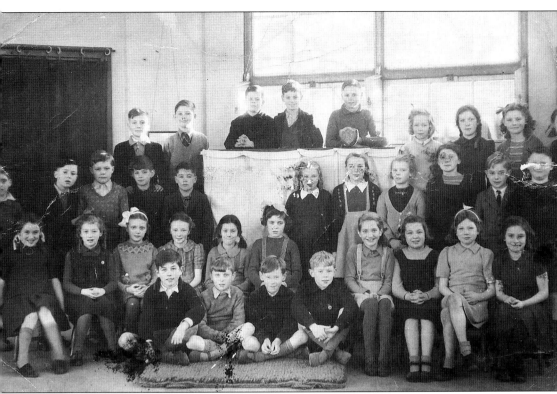

Standard Four pupils at Stakeford Primary School in 1948. Miss Jean Smith of North Seaton was headmistress and Jenny Green, class teacher. This school never entered teams into local schools sports leagues until Mr Bell took over as headmaster in the early 1950s. Stakeford then entered the local Junior Schools league and carried all before them. Back Row, left to right: Evan Martin, Alan Paterson, Alex Dean, Edwin Devine, Tom ('Migsa') Ingham, Nancy Barron, Vivien Woodward, Connie Darling, Wendy Nicholson. Middle Row: George Lillico, Stan Patterson, Alex Swan, Leslie Richardson, Raymond Wilkinson, Florence Darling, Jennifer Carruthers, Mary Allison, Sarah Seeley, David Harvey, Donald McKay. Seated: Jean Shillinglaw, Valerie Nichol, Sandra Wilkinson, Mary Dickinson, Jennifer Burkett, -?-, Isobel Ord, Vivien Sim, Mona Ridley and Pat Hope. Boys at the front: Bob Trewick, Cyril Etheridge, David Newton and Brian Scott. Of the pupils shown, Tom Ingham became a very knowledgeable pigeon fancier, Alex Swan was eventually Sports Editor of the Newcastle Journal, Sarah Seeley married Euro MP Dr Gordon Adam, Cyril Etheridge and Mary Allison married each other and Bob Trewick, one of the sporting Trewick family of Stakeford, played with the Bomarsund cricket team which won the Haig National Village Cup at Edgbaston in 1974.

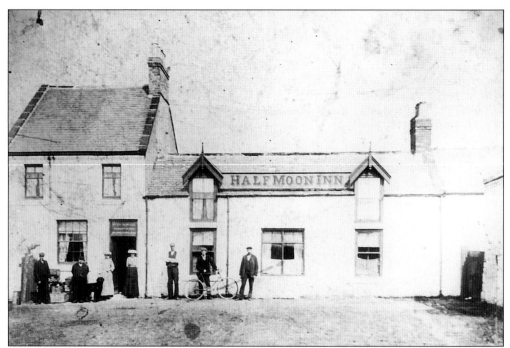

Mr Thirlwell was innkeeper at the Half Moon Inn, Stakeford in late Victorian times. He is pictured here, second left, with his wife, daughter and friends in a scene which has not changed drastically over the years.

Gleghorn's Corner in 1929. With the Lord Barrington pub on one corner and the Guide Post Co-op on the other, with a view down almost to the Bomar pit, there is little wonder this is still a popular Stakeford meeting place. Dr Henry Skinner Brown's surgery, Lelant House, is third down and Dereham Terrace continues down the Winning Road waiting for River Bank to be developed in the years to come.

James Clough in typical pose, on horse back. No one needed his steed more than he did. He managed the Doctor and Sleekburn pits in 1878 until transferring to Barrington and West Sleekburn in 1886. He then lived in Willowbridge House, moving to the newly built Bomarsund House in 1894. He then managed Bomarsund and Barrington from 1906-16, before moving back to West Sleekburn for three years. Mr Clough died tragically in 1919.

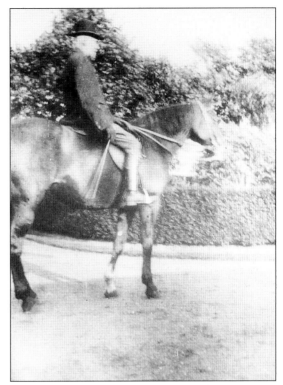

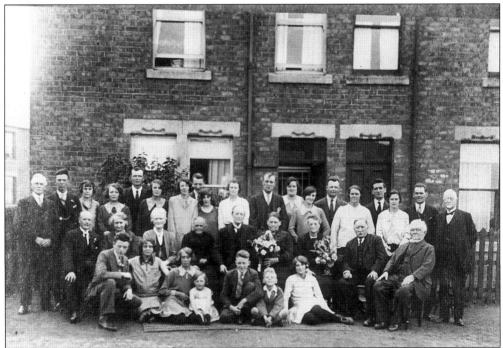

Mr and Mrs J. Straker's Golden Wedding celebrations at No. 6 Ellesmere Gardens, Stakeford, in the early 1930s. In a typical family get-together, Jimmy Scrowther is front left and Northumberland Miners' Secretary Will Straker, extreme right.

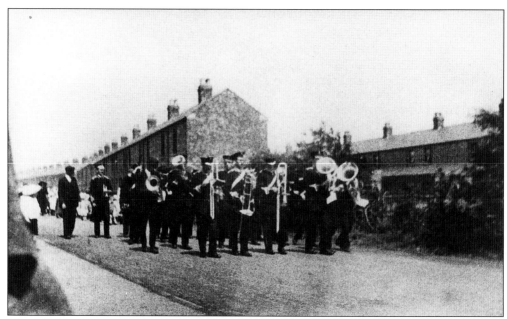

Most of the miners at Bomarsund Colliery lived in the 103 houses of East and West Terrace which geographically were inside the Stakeford border. This 1924 photograph shows the Barrington band leading the Gala procession down past The Green, where Liddell's garage was built in 1955 and private housing later.

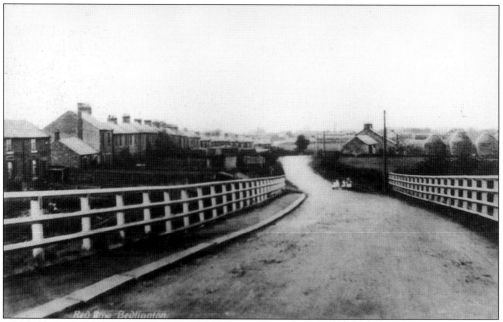

Red Row as many will remember it, with houses on one side and the farm, built in 1849, on the other. The bridge over the Willow Burn was built in 1874, shortly after Lord Barrington and then William Taylor had built houses in the 1860s. The butcher's shop, doctor's surgery and chapel came later.

Five

The Sleekburns
and Cambois

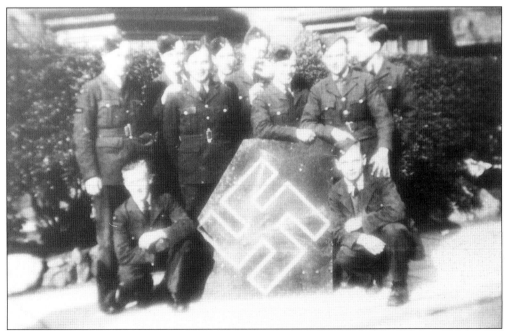

RAF men at Stakeford Road, Bedlington Station with the tailpiece from an enemy aircraft. It disintegrated over the area, leaving this 'souvenir' in the brickyard.

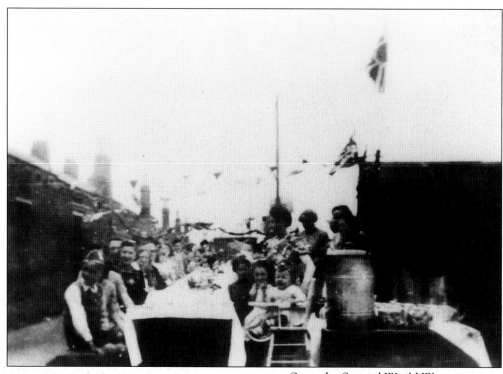

Once the Second World War was over, there was time for celebration everywhere. Here the folk of Bridge Terrace enjoy their victory tea in 1945.

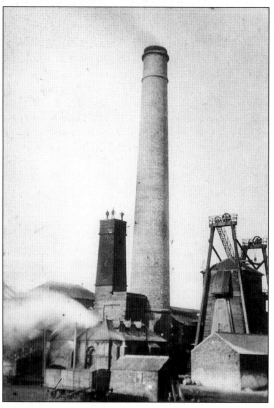

The original Old Pit chimney being demolished in 1905.

Sleekburn Colliery (The Aad Pit) produced its first coal in 1841 but sinking had commenced in 1838. The men needed housing and this street was started to accommodate them. It was originally called Sleekburn Row, then later named Station Row, and eventually South Row. The houses were basic, with no ceilings, no ovens (apart from communal ones outside in street) and no privies (there was a colliery drain at the end of street for sewage disposal). Fresh water had to be carried from the spring at The Furnace. In 1894 these stone habitations were improved by brickwork additions of a front parlour and two upstairs bedrooms, with ceilings to all rooms, and ashpits (netties) outside.

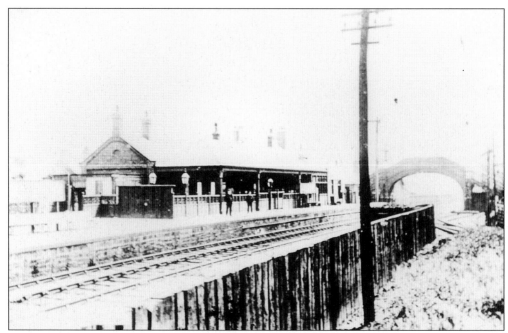

George Stephenson had originally intended to run his main line north of the Tyne through Bedlington's West End from Cramlington, however, Morpeth was given preference. Instead, Bedlington's railway station was set at Sleekburn. This made locals over the years change the place's name from Sleekburn to Bedlington Station (The Station).

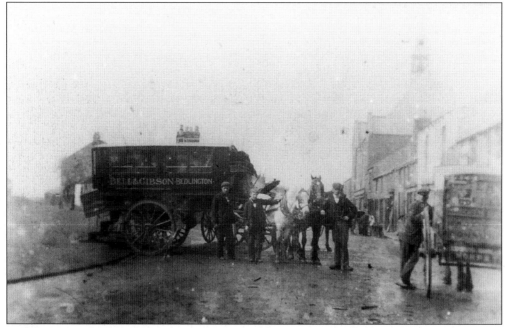

Competition was fierce between horse bus companies running passengers from the station to various parts of the area. This Victorian photograph shows two companies' employees waiting in anticipation.

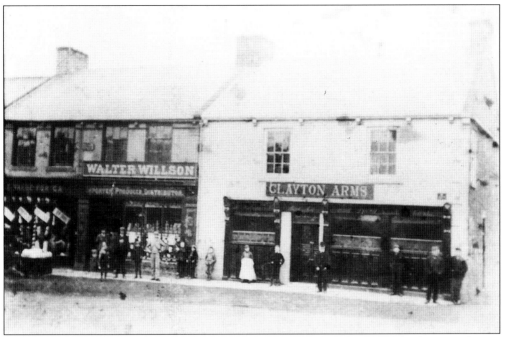

Coal mining and the railway gave work to Sleekburn people but drinking was always a relaxing alternative. This pre 1912 picture shows one of the three public houses in the village. Apart from the Clayton Arms there was the Railway Tavern and the Percy Arms. All three were in business by 1870.

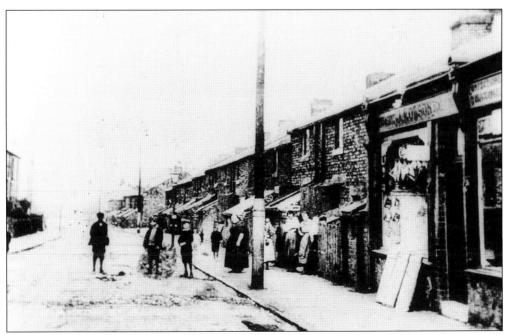

Further down the road from Walter Willson's was a selection of shops to satisfy most needs. The Robson family had a property in Clayton Street, here shown around 1910, for many years.

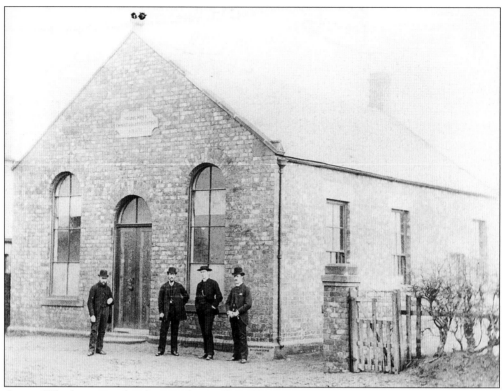

Canon Whitley, second right, together with William Morris, Matty Robinson and Matt Rogers had worked for twelve years to have a YMCA in Bedlington Station. The dream was realised in 1891. This building, which for many years was the Pioneer Boot Factory, is still in use.

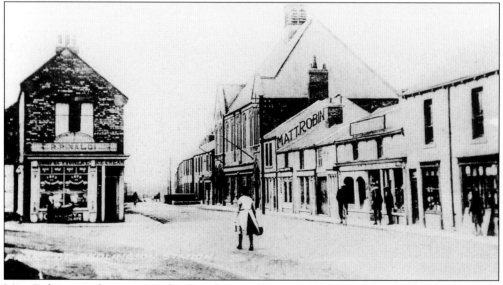

Matt Robinson's shop next to the Cramlington Co-op, served generations of hardware needs. Further down Ravensworth Street was Muters 'pop' factory. Rinaldi's ice cream parlour had taken the place of Hannah's boot and shoe shop which was burned down. Later this became famous as 'Moscy's Corner' when Mr Moscardini took over the premises.

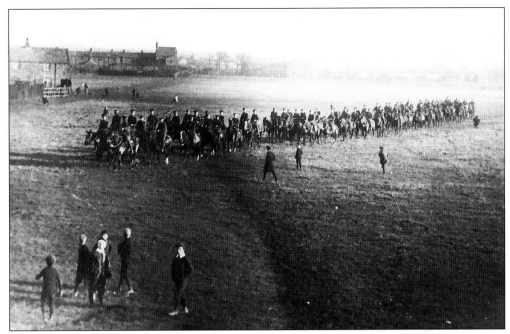

This view taken from The Palace Theatre, opened 1911, shows the Scottish Horse Regiment training in 1914. The area was then known as The Palace Field.

The large King's and Queen's Road council estate was built on The Palace field between the wars.

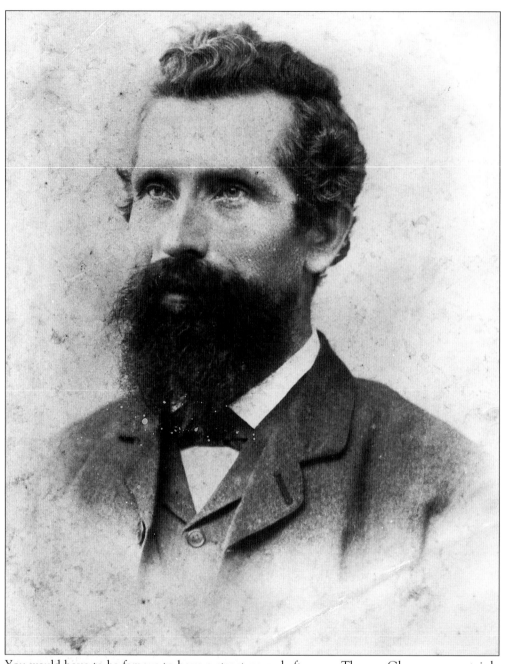

You would have to be famous to have a street named after you. Thomas Glassey was certainly that, both here and in Queensland, Australia. His story is one of hard work from arriving here as a poor pitman in 1867, staying seventeen years before emigrating to Brisbane, where he became leader of the Queensland Labour Party. Glassey Terrace bears his name.

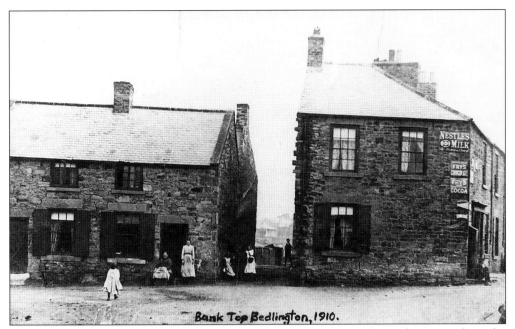

Bank Top Bedlington, 1910.

Glassey Terrace is at Bank Top on the Furnace Bank almost overlooking The Dene where the ironworks were for 131 years. A lot of the Brick Row, Wood Row and Store Row buildings were demolished before 1914. The Bank Top Hotel is on the site of what was the Puddlers' Arms. Melrose Terrace, built in 1912, completed the link to Sleekburn.

Joe Jennings ('Jinks') one of Bank Top's and the Shire's unforgettable characters. He had a carter and carrier's business. The local paper noted there were thirty-eight horses at his funeral in 1928.

Furnace Bank in the early 1900s. This was part of the very busy road to Blyth before the opening of the Kitty Brewster road bridge relieved a difficult traffic problem.

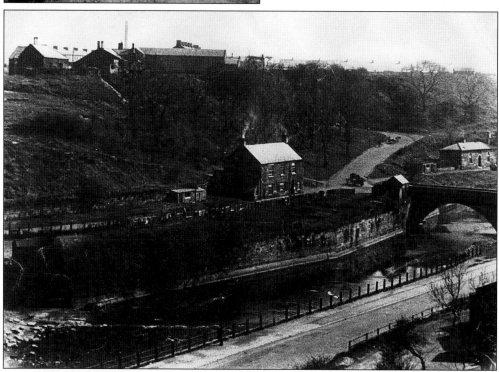

A fine panoramic view of The Furnace and Hairpin Bend, *c.* 1925.

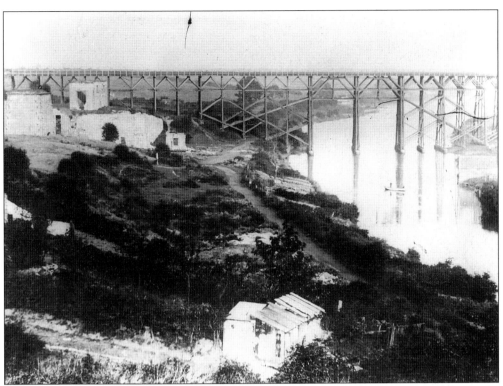

This wooden viaduct was completed in June 1850 at a cost of £6,188 and was paid for by the Bedlington Coal Company. The remains of the old ironworks' winch house is on the left.

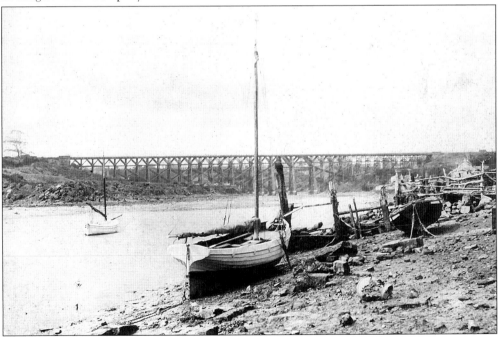

The old viaduct from the east side. The coal staithes can be seen on the right and behind these are the staithesmen's cottages.

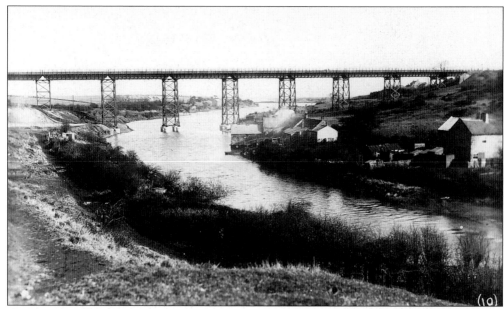

By 1931 the wooden bridge was gone and this metal construction had taken its place.

This view from the mid 1950s, from the Blyth side of the river, shows some of the old ironworks' office buildings on the left (at this time they were dwellings) and Dene House on the right. Michael Longridge, the ironworks' manager, had the house built early in the nineteenth century. Later, the Wood family, produces of mineral waters, lived in the property.

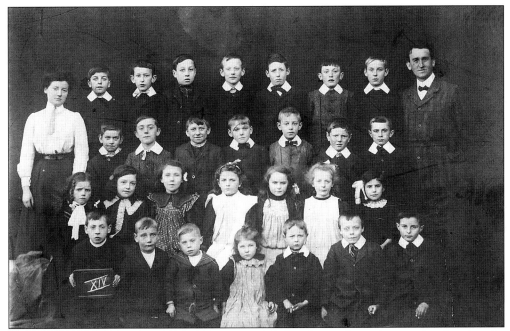

A class at Sleekburn Colliery School in 1910. Mr Smith, on the right, was headteacher for many years and involved himself in many out of school activities.

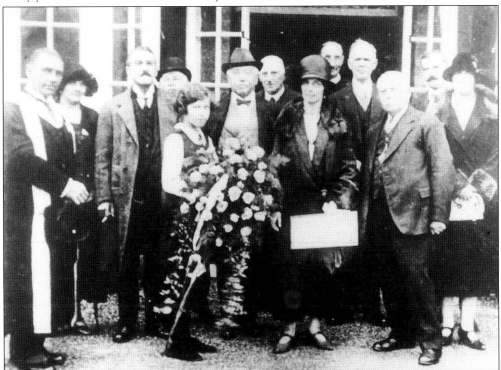

Bedlington Grammar School, opened in Palace Road in 1926. Here, local councillors and Mr Williams, the headteacher, watch senior pupil Ivy Youngs present the Countess of Athol with a bouquet at the official opening.

East Sleekburn, one of the oldest hamlets in the shire, is also known as The Havelock after the local pub. There was a small bell pit in the village in the middle of the seventeenth century, but it wasn't until 1860 that brick houses were built to accommodate miners from West Sleekburn and Sleekburn. These houses, Walker Terrace, were pulled down in 1972. The new road bridge at East Sleekburn was built in 1929. The boundary of East Sleekburn are West Sleekburn to the north, the River Blyth to the south, Sleekburn is to the west and Cambois is the east boundary. There is evidence of a colliery here as far back as 1649. A church rental book for that year states that Charles Reay paid £10 rent for a colliery at East Sleekburn. The village prides itself on its appearance and has won national prizes as a well kept pretty village.

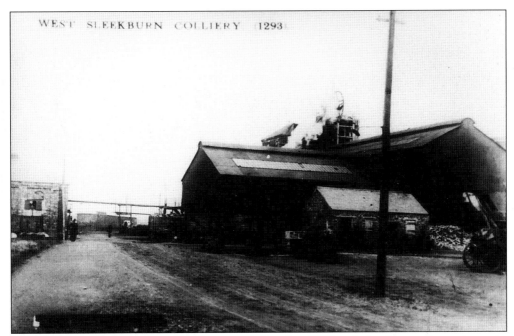

Sinking commenced at West Sleekburn on 1 October 1859 and the first coal was drawn in 1864. The New Winning, or The Winning as it became known, was a thriving community with a population of 77 in 1801, rising to 2,606 by the time of the 1911 census.

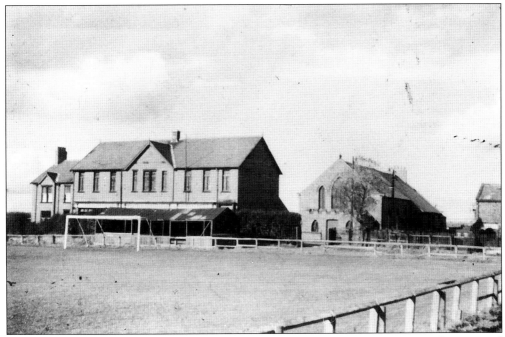

Three things colliery villages were noted for are: Sport, The Co-operative Society and Methodism. Here West Sleekburn's football ground, the store, behind the goal, and Wesleyan Chapel, squeeze into one photograph. The Welfare Park was completed in 1928, the first Co-op was dated 1891 and this chapel opened in 1907.

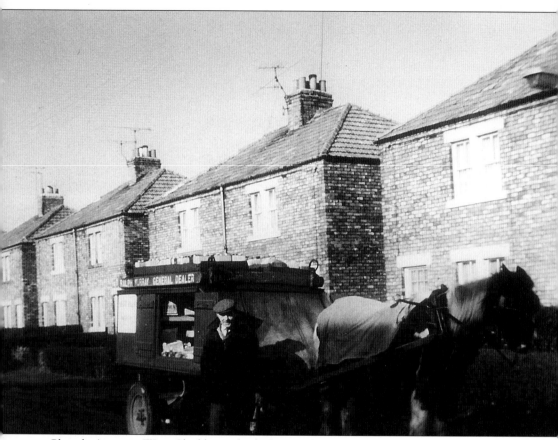

Church Avenue, West Sleekburn, built from 1923-24, was made up of superior type semi-detached houses with all facilities under one roof. Even a bath was available under the scullery bench, which could be filled by hand from a set pot in the corner. Ralph Murray's horse and cart was an anachronism. For two generations old Ralph, then his two sons, Ralph Jnr and Mark, led a horse and cart through the Shire selling oil and all manner of hardware items. When almost every other hawker had taken up motorised transport, the Murrays continued with their special cart and horse, much to the delight of locals, especially rose growers who reaped a manure benefit. When hawking was finished for the day, the Murrays parked their cart behind the Stakeford shop and walked the horses to their stables at West Sleekburn Farm, Bomarsund. Alice and Marie, the two Murray daughters, ran the shop and post office at Stakeford for many years.

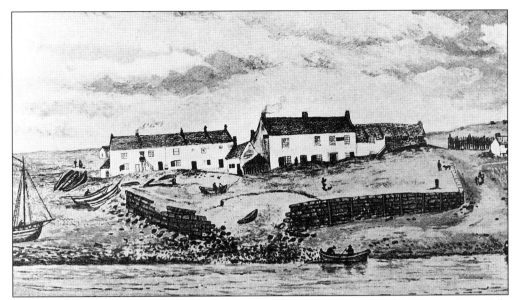

A print of North Blyth in 1840 when fishing was the main occupation. Many years later Dale Street, Worsdell Street and Gray Street, with the Railway Club, made up what was a mainly railway orientated area.

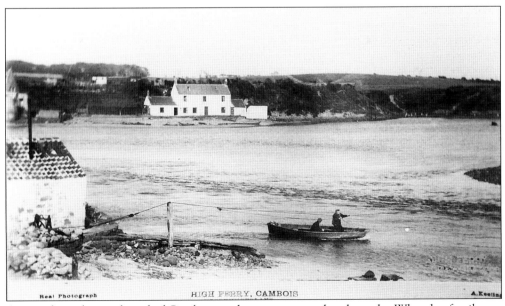

A view from the south end of Cambois to the extreme north, where the Wheatley family ran their ferry for many years. The ferryman pulled on a wire rope to move the boat between Cambois and the North Seaton links. The building in the centre is the Ship Inn at North Seaton.

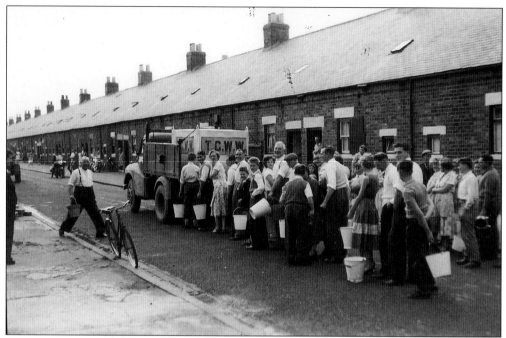

The years 1955 and 1959 had hot dry summers and water bowsers were busy in most English streets. Cambois was no exception. Here, Watergate's good natured residents queue up, enamel buckets at the ready.

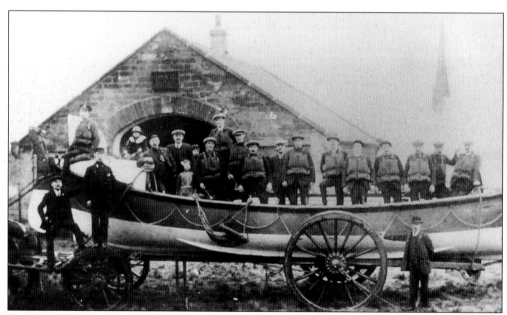

Cambois lifeboat crew, *c.* 1914. This was the only British lifeboat which could at one point in its history claim to be run totally by pitmen. When the station closed the boat was transferred to a new location on the Isle of Wight.

Six
Churches and Congregations

In the days before radio and television, the churches often provided entertainment for young and old of both sexes. Many churches had something to visit each night of the week. Like many mining areas, Bedlingtonshire has a large number of Wesleyans and Primitive Methodists, but the intake, in the mid-nineteenth century, of Southern Irish escaping the potato famines, ensured many Roman Catholics are here too. This photograph is staged outside the Church of Christ on Front Street West.

The old Baptist church in the Baptist Yard, off Front Street West, was purchased by the coal company and used for miners' housing in the last century. As this photograph shows, bricks, an easy alternative to stone, were used to build an upstairs to the property, which was demolished in the early 1960s.

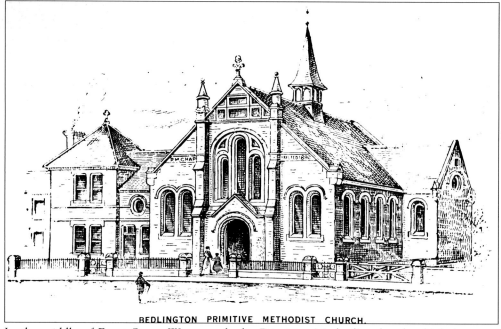

BEDLINGTON PRIMITIVE METHODIST CHURCH.

In the middle of Front Street West stands the Primitive Methodist church which is now a private residence. Built for £1,500 in 1893, it stands out from the rest of the buildings on the north side of the street.

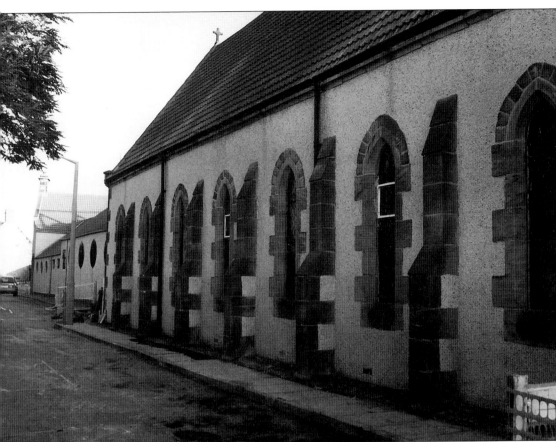

In 1865, the generous Mrs Sidney of Cowpen gave £800 towards the cost of a Catholic school and house which totalled £1,117. Eventually the school became the church and the four main rooms of the present presbytery are the old school house. Bedlington and Cowpen Catholics were linked until 1876 when a separate parish was formed and the first baptism was recorded on 3 December of that year. The original church served Bedlington's Catholic community until 1992, when it was replaced by the present building.

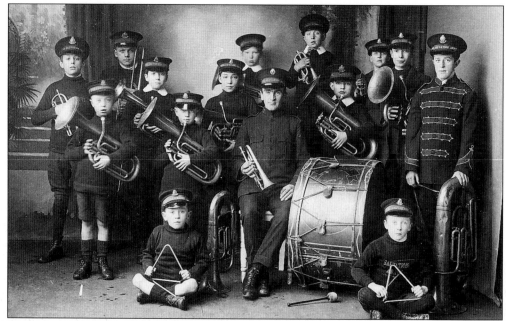

The Salvation Army has deep roots in Bedlington. Founded in 1880, it has been on its present site at the top of Hartford Road since that time. The band pictured here was formed in 1916 by Captain Bingham. The original Army building was a theatre, once owned by Mr John Dowson.

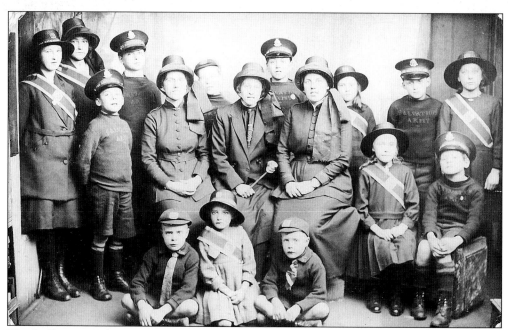

The Bedlington Salvation Army Singing Company in 1922. Among the members are, Phoebe Hemsted, Mary and Stephen Hogg and Lucy Slaughter.

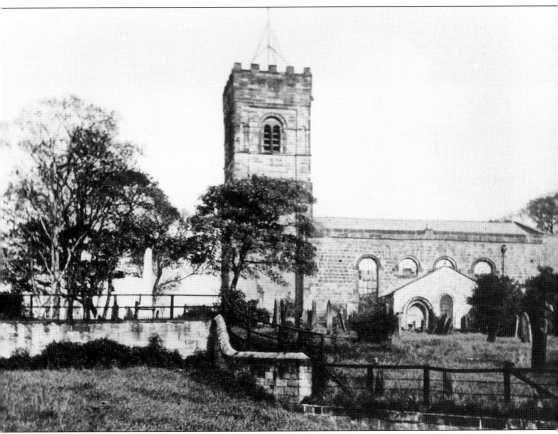

St Cuthbert's church from the south. There has been a church on the site for over one thousand years and the church's own history takes us back to the first incumbent Eliaf Tod (c. 900). The development of the ironworks and the pits in the nineteenth century meant more seats were needed and in 1817 the church was extended. Thirty years later the chancel was enlarged. Another twenty years passed and the old Norman tower was replaced by the present structure and a new bell, which is still in use, was put in place. In 1912, the 1817 circular gallery was replaced by the Burdon Memorial Aisle on the north side. In 1921 a memorial chapel was formed for the fallen in the First World War.

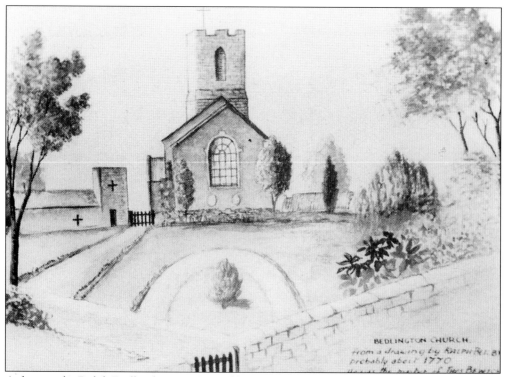

A drawing by Ralph Beilby showing St Cuthbert's from the main road, *c.* 1770.

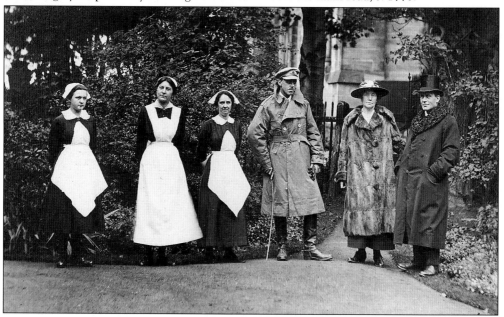

Alexander Campbell-Fraser MA became vicar at St Cuthbert's at the outbreak of the First World War. He was a scholar of some distinction and in 1924 wrote and published a comprehensive history of his church. He handed over to John Purvis in 1928. Revd Campbell-Fraser and his wife are on the right here, with son Alex, on leave, in 1918. Nancy Grieve is on the left.

BEDLINGTON PARISH MAGAZINE.

Clergy—Rev. R. J. PEARCE, D.C.L., *Surrogate.*
Rev.
Rev. J. F. MARTIN, B.A.
Clerk and Sexton—G. J. HAYES, Ridge Terrace.

Sunday Services.

PARISH CHURCH.

8.30 a.m., Holy Communion (except on 1st Sunday in the month).
10.45 a.m., Morning Service and Sermon ; also Holy Communion on 1st Sunday in the month.
2.30 p.m., Baptisms and Churchings.
6 p.m., Evening Service and Sermon.

SLEEKBURN AND NETHERTON SCHOOL-ROOMS.

6 p.m., Evening Service and Sermon.
Children's Services on the 1st and 3rd Sundays at 3 p.m., at the Parish Church and Sleekburn respectively.

Week-Day Services.

Wednesday, 7.30 p.m., at Sleekburn.
Thursday, 7.15 p.m., at the Parish Church and at Netherton Rows.

SUNDAY SCHOOLS—Bedlington, Whitley Memorial, and East Schools, at 2 p.m.
 Sleekburn and Netherton Rows, at 2.30 p.m.
SOWERS' BAND on Fridays at 7 p.m., at the Vicarage, fortnightly.
BAND OF HOPE during the winter months, weekly at East School on Wednesdays; fortnightly at Sleekburn on Fridays; at 7 p.m.
BOYS' CLUB on Fridays in the East Schools, at 7 p.m.
CHURCH LADS' BRIGADE on Tuesday evenings in Whitley Memorial School at 7.30.
MOTHERS' UNION meets quarterly at Bedlington, Sleekburn, and Netherton at dates to be announced.
MOTHERS' MEETINGS are held fortnightly at Sleekburn and at the Netherton Mission Room.
G.F.S.—Library—In the Vestry, alternate Fridays, 3 to 3.30.
 Bible Class at Mrs. Maclaren's, alternate Wednesdays at 6.45.
SEWING MEETING at the Vicarage, on Mondays at 6 p.m.

N.B.—Notices of Baptisms, Marriages, or Funerals must be given one day previously to one of the Clergy.

Price One Penny.

The cover of St Cuthbert's church magazine of May 1898. Some will agree it is a more sophisticated offering than that of one hundred years later. The many facilities and options open to parishioners, make interesting reading.

The Primitive Methodists were popular with their Sunday Schools and had interests for all the members of the family. This is the 'Ranters' Chapel' at Choppington which was built in 1879. The chapel was burnt down in 1895 but rebuilt the same year. This photograph was taken in 1900.

Thomas Burt became secretary of the Northumberland Miners' Association in 1865 while working at Choppington and held the office for twenty-seven years. He became Liberal MP for Morpeth in 1875 at the age of thirty-eight and was looked upon as the first ever working class MP. He held his seat until resigning in 1913. Burt was a keen Primitive Methodist, like many union men, and Choppington was his church. Many were the occasions that Burt honed his public speaking ability from the Choppington pulpit.

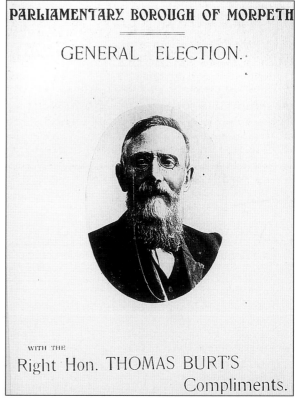

PARLIAMENTARY BOROUGH OF MORPETH

GENERAL ELECTION.

WITH THE

Right Hon. THOMAS BURT'S
Compliments.

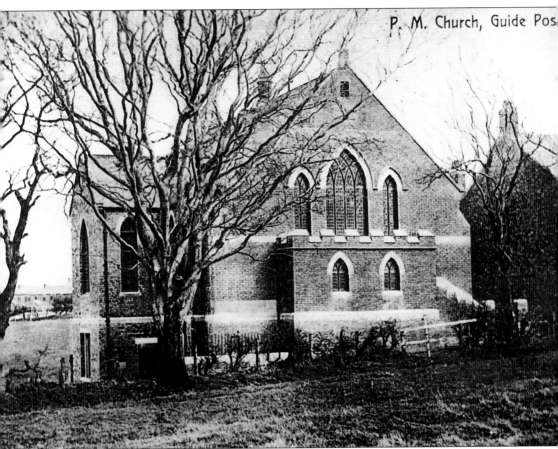

The Primitive Methodist church at Guide Post was better known as 'Sheepwash Bank Chapel'. This photograph, taken shortly after its completion in 1907, shows what a magnificent building it was. The church, or chapel as Methodists usually named their place of worship, took the place of the old chapel in Gordon Street. The trustees let their old property for dances, meetings etc., and the Methodists sold out to Mr Walker Charlton for £129 in 1918. Mr Charlton turned the old chapel into a cinema and dubbed it The Olympia. The demise of The Olympia and surrounding properties came between 1954 and 1958 when the local authority cleared the area to make way for new developments. Sadly, the Sheepwash Bank Chapel has also gone.

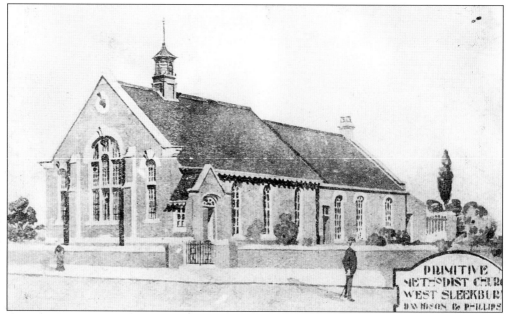

This architect's drawing of West Sleekburn Primitive Methodist church was made in 1905. The church was completed a year later and replaced the original building of 1869. This meant there were three religious establishments catering for the small village; Church of England and Wesleyans being the other two. The church was pulled down with the rest of the village in 1958.

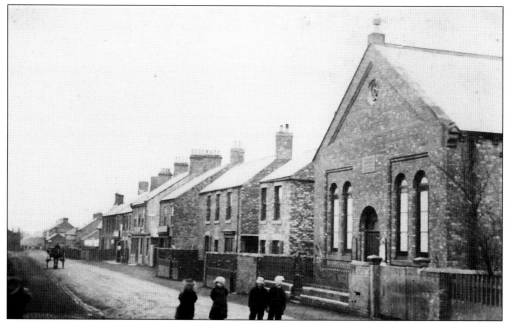

Many of the old churches have now gone but the Colliery Chapel at Bedlington Station is still going strong as an out and out Methodist stronghold. This photograph, from around 1900, shows the chapel on the right. It was built in 1883 and faced the main entrance to the 'Aad Pit'.

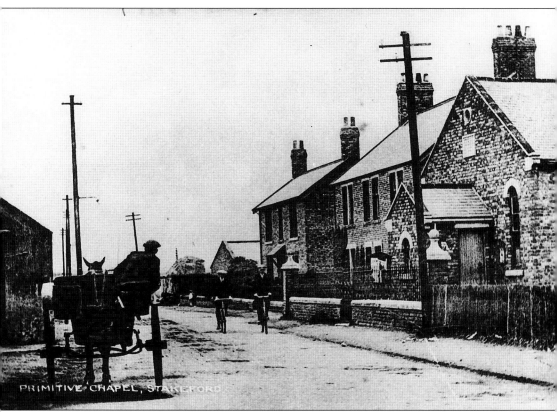

PRIMITIVE CHAPEL, STAKEFORD

The Stakeford Primitive Methodist church was built in 1880 for £257 7s 10d with a £120 mortgage which was paid off in twenty years. The church seated 152 but more often than not seats had to be put down the aisle each Sunday night. The Stakeford Methodists had been organised at least nine years before this and they held meetings in a cottage provided by Miss Ord of Stakeford Farm. The Blyth Circuit quarterly report first mentions Stakeford in March 1871, stating that the Sunday School had nine teachers and forty scholars. The church receipts for the year were £2 7s 9d and the expenditure was £1 14s. The new church built next to this building was opened on 20 April 1968.

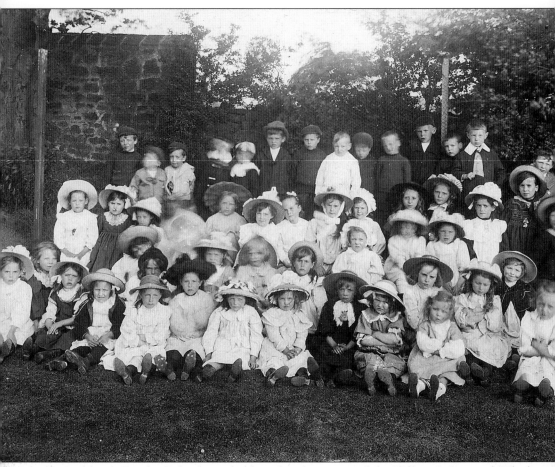

St Cuthbert's Sunday School was held in the classrooms of the Village Infant and Whitley Memorial Schools at 2.00 pm every Sunday afternoon. As this 1905 photograph shows, there must have been a large turnout of pupils. This was only the Infant section (three to seven year olds) and one can imagine the chagrin of some children having to attend their own school building six days a week. A few of the pupils shown here can be identified as Henry Richardson, A. Smith, E. Smail, I. Smail, J. Cairns, Margaret Young, E. Steel, Mary Hay.

Seven
Trade, Transport and Industry

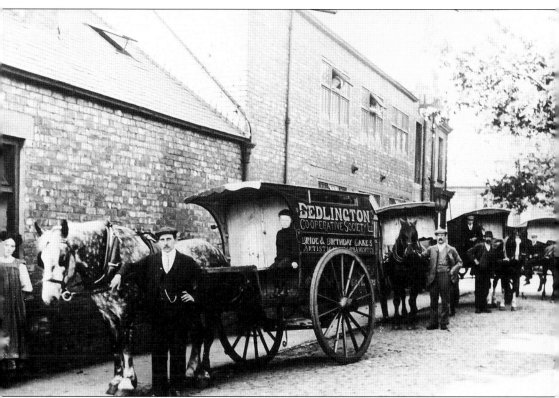

The Co-operative Societies had a great influence on people's lives. The quarterly dividend was often a family's only means of saving and almost everything from a tin of shoe polish to a bedroom suite had Pelaw or Blossom Street, Manchester stamped on it. This lovely photograph shows the store baker's carts outside the Hollymount bakery around 1905. The Hollymount Estate had been purchased by the Society in January 1892 and the bakery business started in April 1898.

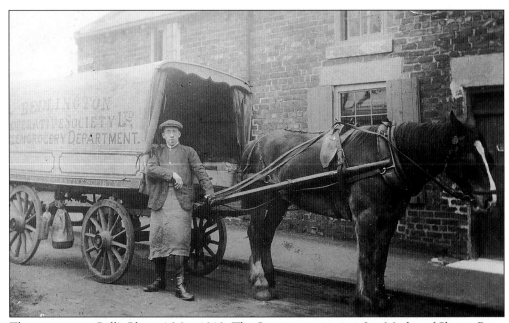

The entrance to Bell's Place, 1 May 1913. The Store greengrocer is Joe Marley of Shiney Row. The Co-op's greengrocery business began in May 1894.

The Co-op headquarters in Manchester had produced *The Wheatsheaf* for a number of years before the Bedlington society decided to distribute the magazine to its members. The first issue was released with Bedlington's name on it in December 1897.

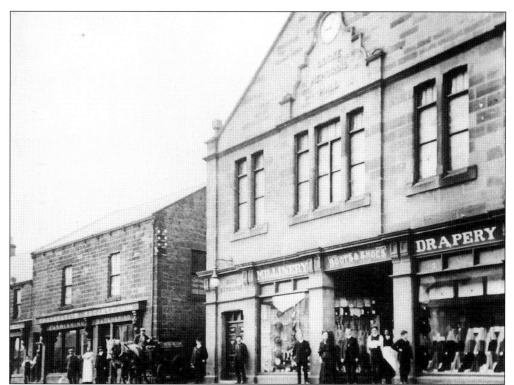

Bedlington Co-op was up and running in June 1861 after initial meetings held upstairs in the Northumberland Arms. This photograph, taken shortly after the opening of the Locke Hall in 1902, shows the progress made in little over forty years.

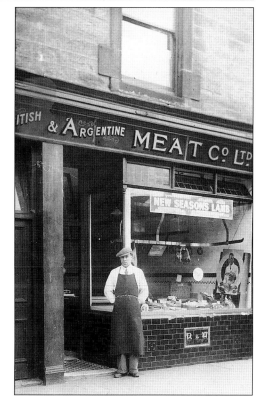

If the Co-op had real competition in any one aspect of retailing, it was in butchering. For many years 'The Argentine Butchers', a shortening of the title shown here, stood where Chris Baird's photographer's shop is now. Here, in the 1930s, is the manager Ernie Johnson.

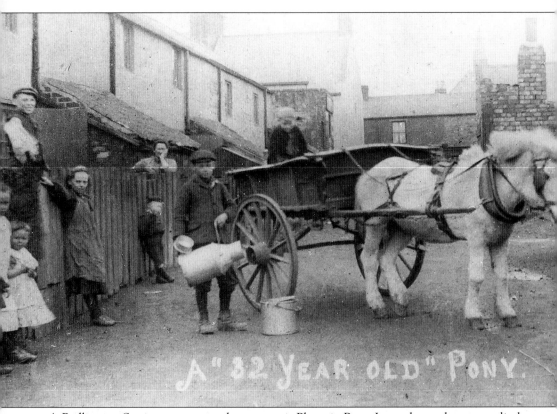

A "32 YEAR OLD" PONY.

A Bedlington Station street, now long gone, is Phoenix Row. It was better known, politely, as 'Chamber Pot Raa' from some of the residents' habit of 'airing' the dreaded pot on the rain barrel. The Row was behind Clayton Street opposite The Palace (Wallaw). Dairylad Tommy Coxon of Red Row, typified milkmen of this time, around 1908, with open milk churns and billycans. Some customers complained that Tommy's pony was a flea-bitten old hack and should be replaced because the milk could be affected. This, however, apart from being a family pet, was a good workhorse that knew every customer's door in the Shire. A replacement was not on, until one morning Tommy went to the field to bring the horse for work and found someone had shot it. Phoenix Row itself saw its last days in 1937.

Bedlington was served by a number of dairymen over the years, but none were in business longer than the dairy run from Demesne Farm by the Abbs family. The family connection (later to become J.G. & E.W. Elliott) with the farm, lasted over 150 years. Well known Bedlington character Ted Abbs is shown here proudly showing off Silver.

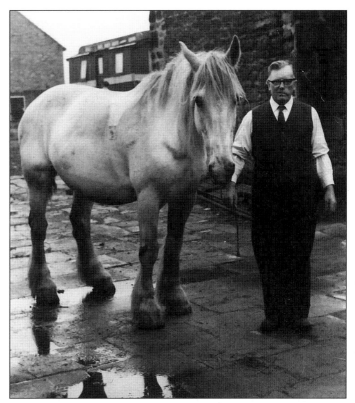

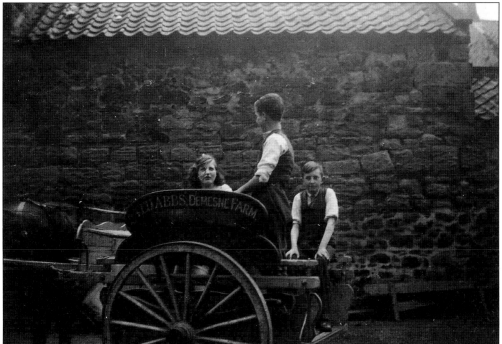

The stable yard at the back of Demesne Farm, with Ted Abbs' lovely old milk float and helpers Ivy Thornton, Tommy Hepple and Jimmy Robertson.

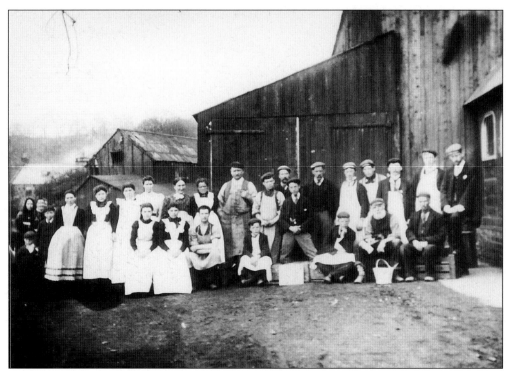

If milk wasn't your drink, perhaps you were one of the many who enjoyed a bottle of 'pop'. Woods manufactory down Furnace Bank produced mineral waters of all flavours. Woods had a number of factories on Tyneside and in Northumberland. Here the Bedlington staff from the early days of this century take a break to pose. The man with the crestfallen look on the far right is Mr Robinson, the company accountant.

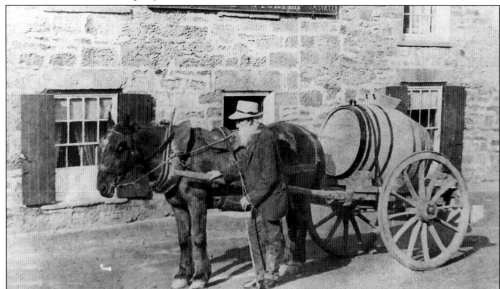

Matty Wintrip liked water, as it provided his living. He filled his mobile barrel at The Furnace Spring and toted it round the Shire at $\frac{1}{2}$d a bucket. It's no coincidence he's pictured outside the Rose & Crown at The Furnace. Rumour has it he enjoyed a tipple of the hard stuff too.

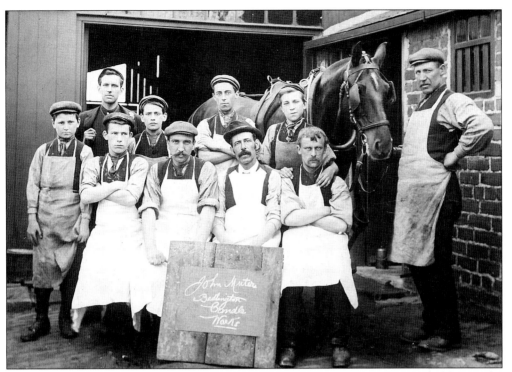

John Muter's workforce produced candles at the south end of East View, Sleekburn. The ironworks buildings down Furnace Bank provided factory space for another candlemakers, Graham & Bestford's Dene Candleworks, established in 1898.

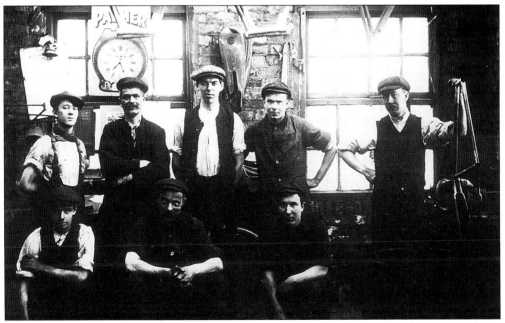

Inside Scott's iron foundry, just off Front Street, Bedlington, c. 1912. Scott's was famous for its bicycles, but also made parts for collieries and shipyards. The building is still to be seen behind Elliott's Garage.

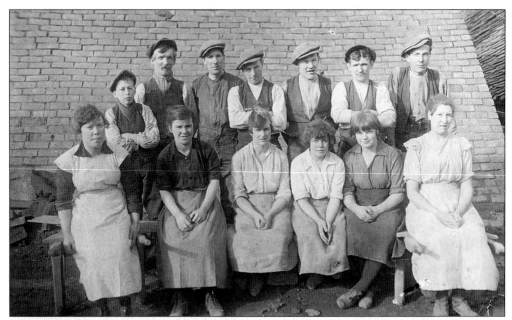

Barrington brickyard workers in 1924. A man's average pay was £3 10s a week at that time, which was regarded as good money, with bonuses on piece work. It was a hard day's work from 8 am until 5 pm. Women could earn two thirds of the men's wage.

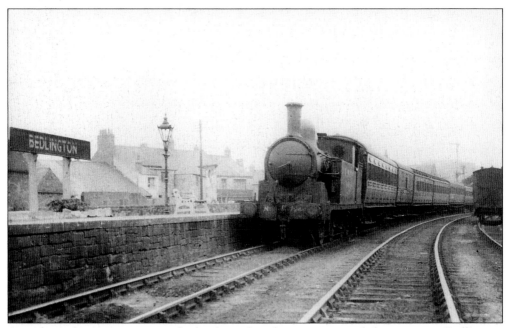

A ready made transport system for bricks and coal was just around the corner at Bedlington Station. Here 'the tankie' arrives from Newcastle Manors on its way to Newbiggin. The Blyth & Tyne line closed to passenger traffic in 1964 after seventy-five years service.

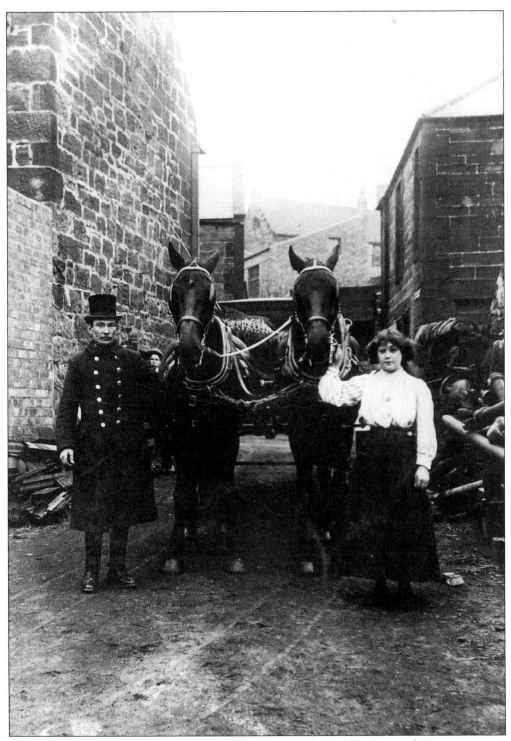

Jimmy Bower set up a charabanc and coach business in Muggers Neuk in mid-Victorian times. He also hired out marquees and tents. Here are Jimmy's son, Robert and Bertha, Robert's half sister, around 1900.

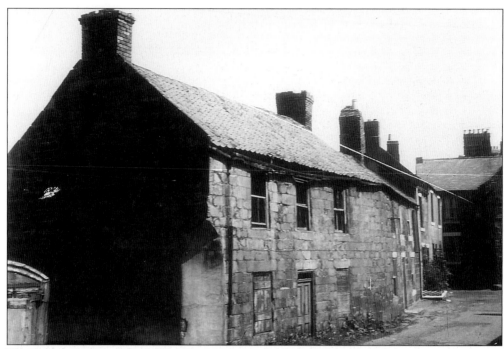

The Bowers' lodging house and other Neuk property shortly before demolition. At the end of this street and around the corner was Rosella Place, also now a place of the past.

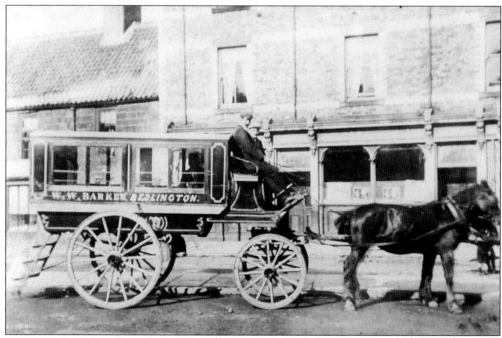

The horse bus trade from Bedlington Market Place to the railway stations at Sleekburn and Netherton (the station's name was later altered to Stannington) was a lucrative one. Billy Barker's bus often doubled as a hearse. As one contemporary wag put it: 'God only knows who's been in this bus today'.

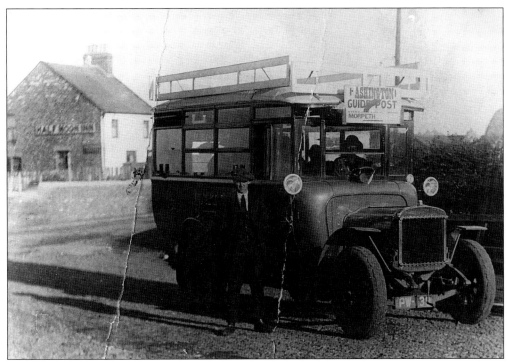

By the 1920s transport had become much more sophisticated. This United bus parked at Gordon's corner, Stakeford, in 1921, was a coach set upon the chassis and engine of a First World War truck. The driver is David Henderson and the conductress inside is Lillian Henderson, David's sister.

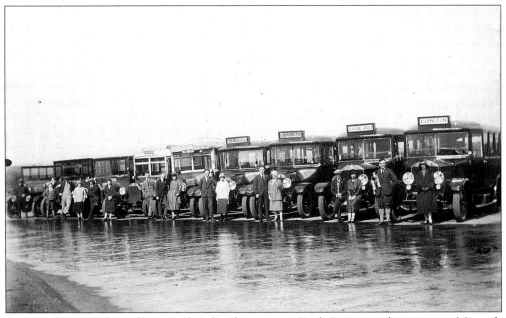

Amos and Proud's fleet of buses at their headquarters at Guide Post, now the garage on Morpeth Road. This photograph, from around 1925, suggests a thriving company, which successfully ran services throughout Northumberland, at least until 1928.

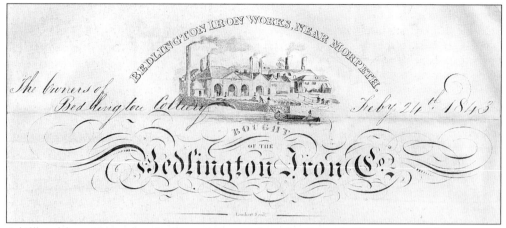

A billhead from 1843, when Bedlington Ironworks was at its peak. The success of this company turned a quiet, rural area into one of 'noise, smoke and trade', to quote a contemporary writer.

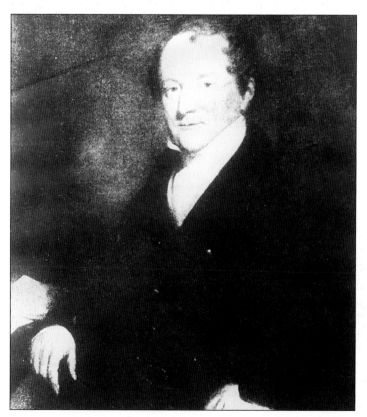

Michael Longridge was the man who transformed Bedlington Ironworks. He arrived as manager around 1809 and his business brain soon made improvements in social and economic areas. An engineworks was established in 1837 and over 400 engines were built for customers all over Europe.

Sir Daniel Gooch is probably Bedlington's most famous son. Born in the town in 1816, he left when aged fourteen and with his father moved to Wales. His experiences as a boy running around Bedlington Ironworks, where his father was book-keeper, stood him in good stead, as he was appointed locomotive engineer on the G.W.R. by Brunel in 1837. Gooch had a wonderful career; he laid three lots of cables across the Atlantic, was known world wide as a consultant engineer and was knighted by Queen Victoria, in 1867, who insisted he drive her locomotives. Gooch died in 1889.

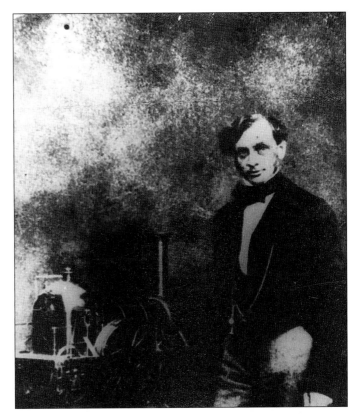

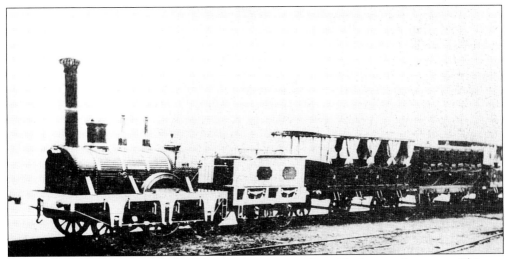

The Iron and Engineworks were well known concerns in the mid-nineteenth century. This was mainly due to the malleable iron rails produced at the ironworks, and the engines, both broad and narrow, built at the engineworks. This locomotive, 'The Bayard', was specially made in 1839 for the Naples-Portico Railway. It now stands in Rome's Railway Museum.

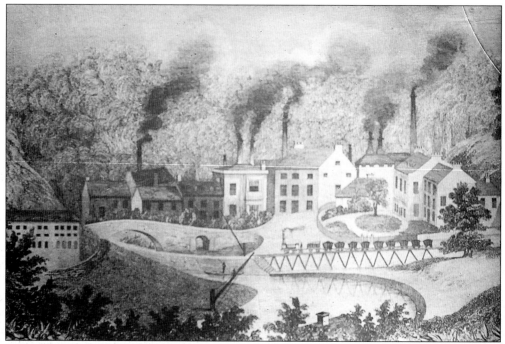

A painting of the works in Blyth Dene, c. 1840. The engineworks are on the left of the picture on the Blyth side of the river.

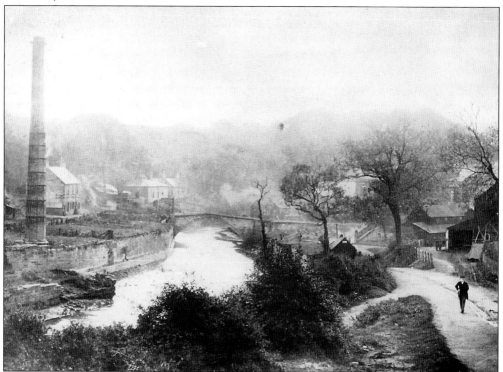

The same scene, sixty years later, but puddling had long since stopped. The works lasted from 1736-1867. This photograph is dated 1902. The chimney went shortly after this.

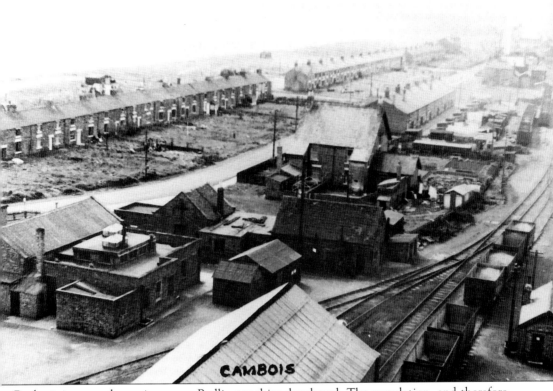

CAMBOIS

Coal mining was the main reason Bedlingtonshire developed. The population, and therefore housing, increased from the middle of the nineteenth century. Cambois Colliery was typical of many with the ribbon development of housing. Cambois produced coal for just over 100 years, the last day of production being 20 April 1968. In the foreground of this colliery based scene is the pit canteen and ambulance house. Further down on the right are Office Houses, Stable Cottages and Foster Terrace. In the distance, on the left, is the Beach Chapel, next to Chapel Row. Store Row comes next with Sinkers Row on the top left. Cambois stretches almost exactly two miles from the Blyth Ferry in the south to Wheatley's Ferry in the north, across the Wansbeck. Cambois has had many phonetic spellings in books and on maps over the years. The word is pronounced 'Camus' after the Irish word meaning a bay. The present spelling of Cambois has been on most maps and in reference books for the last 300 years.

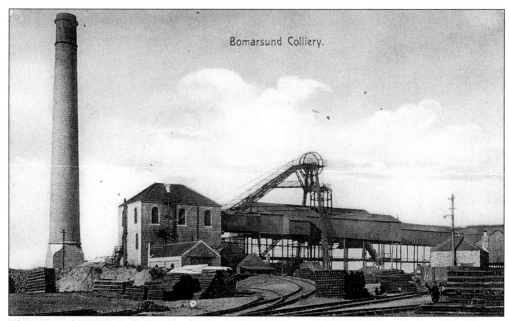

Bomarsund Colliery.

The original Bomarsund is in the Baltic, part of the Aarland Islands group. It was a Russian fortress during the Crimean War, taken by the allies on 13 August 1854. News reached this country fifteen days later, the day Barrington Coal Company laid the foundations for the Sinkers Row at New Barrington Pit. The cottages were named Bomarsund, although they were later called Ivy Cottages. Subsequently the pit took the name Bomarsund and 'New Barrington' was forgotten about. Flood water caused problems and Bomarsund pit as we know it didn't commence until January 1907. Back overman Steve Martin was the last man out when the pit closed on 23 October 1965.

One of the great union men of the twentieth century was Will Lawther of Barrington. Son of a well known Methodist lay preacher Robert Lawther, Will was, like many of the Methodist persuasion, closely concerned with social and political needs of his time. Will was President of the National Union of Mineworkers and was knighted in the later years of his life for his social services. Sir Will died aged 87 in 1976.

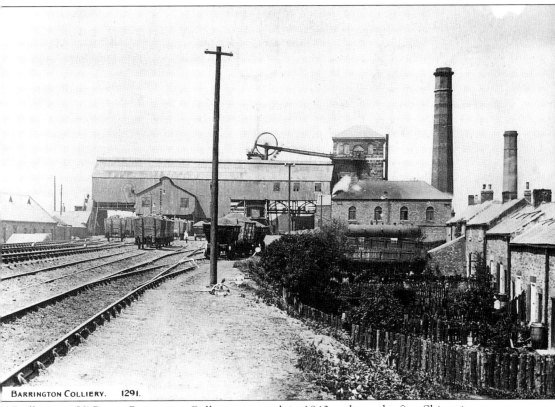

Bedlington 'H' Pit, or Barrington Colliery, was sunk in 1840 and was the first Shire pit to stop work in August 1936. This photograph shows how close the old school, closed in 1913, was to the pit. Sinkers Row, later Stone Row, is on the right.

This Barrington Colliery Street (Victoria Row) was demolished in the 1960s. Many colliery streets had spick and span houses inside and out.

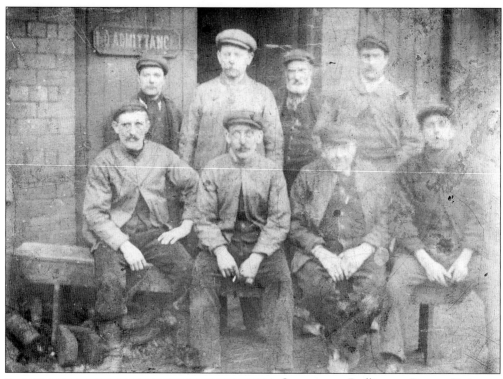

Screeners at Bedlington Doctor Pit in 1905. The old man, second from the right in the back row, was 72 years old.

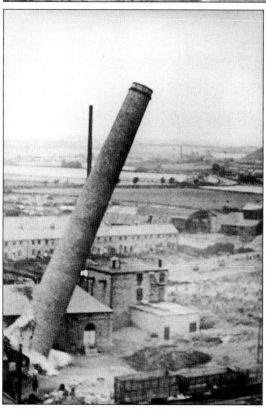

The end for the Doctor Pit Chimney, felled on 8 August 1952. The colliery itself stopped production on 2 March 1968, having produced coal since 1854.

Eight
At Leisure

What could be more relaxing than a night of escapism at 'the pictures'? The troubles of the war were forgotten for a couple of hours in early 1945 when these films were shown.

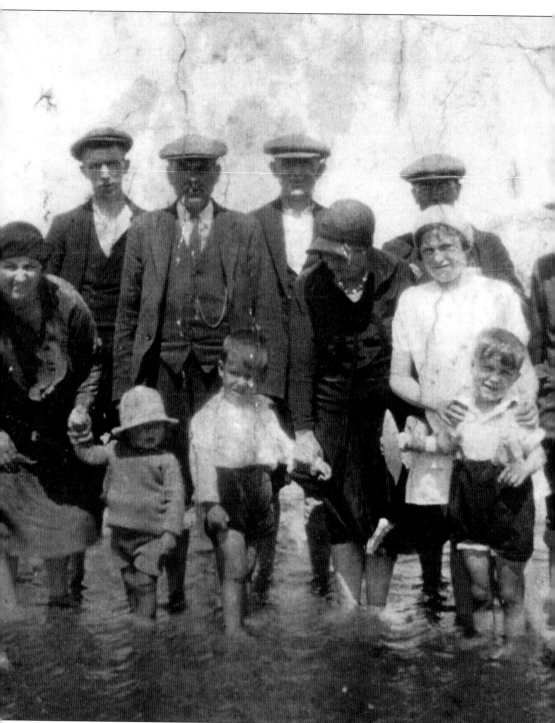

Maybe a plodge in the sea at Cambois was the answer. These hardy Stakeford folk often made the five mile round trip on foot carrying bags and the bairns. Here, in 1931, are Mrs English, Joe Jordan, Jack Gall Snr, Jack Common and Mrs Common, Fred Mollon, Ella Common, Jack Gall Jnr, Alex (Pat) English, Ken Jordan, Bobby Gall.

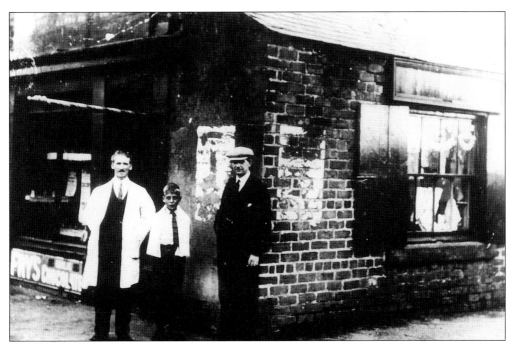

Who will ever forget the 'crack' (conversation) over many years at the barber's. It was an uplifting, as well as hair losing experience. This barber's shop at West View, Stakeford, opposite the chapel, was a forerunner of Jos. Nicholson's and Geordie Bibby's.

Concerts weren't everyone's cup of tea, but the Locke Hall had its share of dances and shows over the years from 1902. This programme was for its very first Celebrity Concert in 1948, starring international singers Elena Danieli and Arthur Fear. Locals were not to be outdone, as Bill Robinson was the conductor and Ada Johnson, the pianist.

Bedlington Male Voice Choir

PROGRAMME

OF THE

FIRST CELEBRITY CONCERT

HELD IN THE

LOCKE HALL, BEDLINGTON,

—ON—

SUNDAY, OCT. 17th, 1948,

AT 2·30 P.M.

Programme - - **3D.**

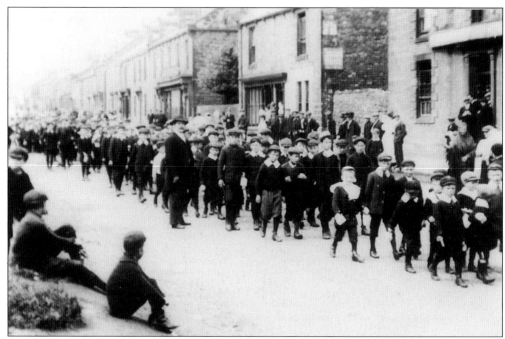

A gala day before the First World War and the colliery children are marched down the East End to the picnic field, now Attlee Park, for fun and games.

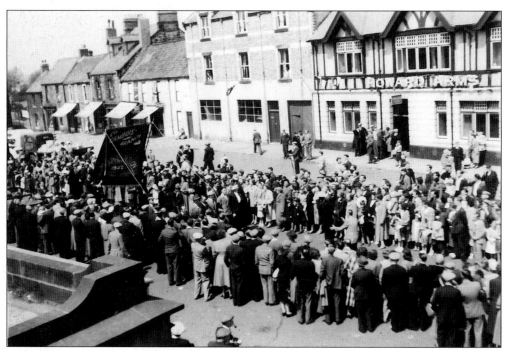

Another gala, this time the Miners' Picnic which was held continuously, from 1952, at Bedlington. This early Bedlington Picnic shows the Cambois banner and band leading the procession through the Market Place.

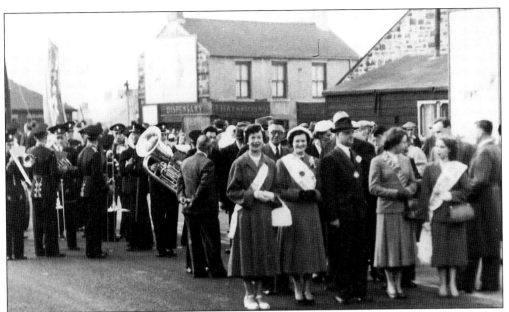

Jill McNair, Coal Queen, and Brenda Clarke of Cambois, her maid of honour, wait for the procession to be organised at the 1952 Picnic. This photograph was taken in the Railway Tavern car park at Bedlington Station.

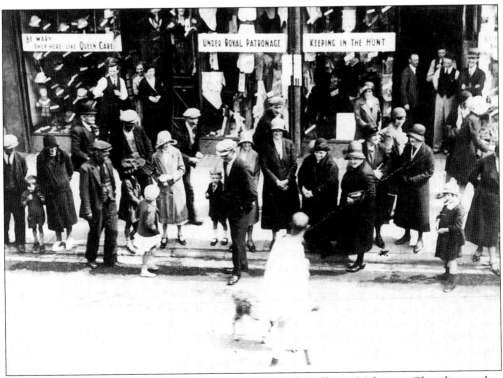

Twenty-one years before the previous photograph, Bob Mills, as Mahatma Ghandi, marches past Barney Ward's shop, as part of another procession.

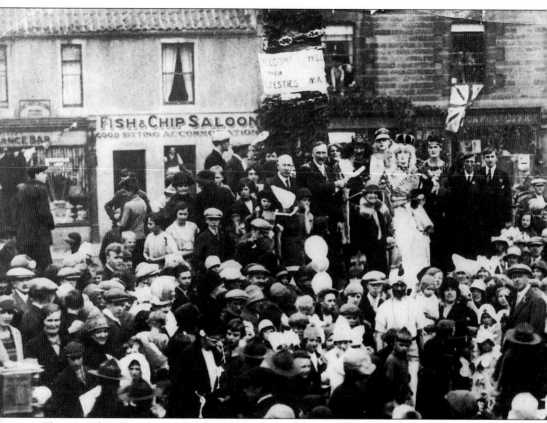

The annual Carnival was always a highlight in the Bedlington social calendar. This, the 1928 Carnival, had newsagent Bob Watson as King and Mr Cunningham, a local shopkeeper, was Queen. Others in the picture include, Fred Carr, newsagent, John Little, auctioneer, George Rockett, cobbler, and George Weightman, schoolteacher. In the background, through the fish and chip saloon window, can be seen Bart Bacci, who had recently bought the premises and the tea-shop next door. The Baccis were to be in business in the town for the next sixty years.

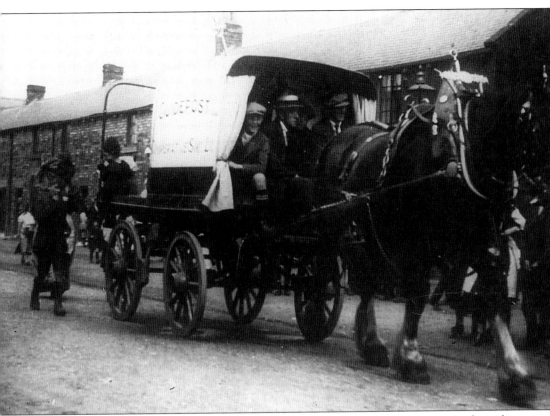

Making its way to Bedlington for the Whit parade, this Guide Post Co-op cart passes through Scotland Gate.

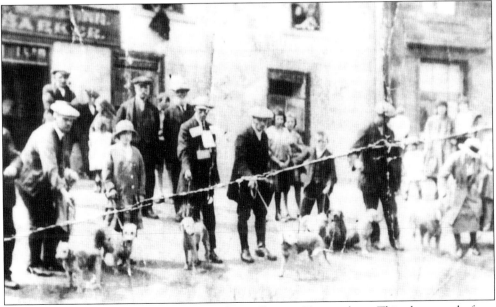

Always part of any carnival tradition was the Bedlington Terrier show. This photograph, from around 1920 and rescued from a dustbin, shows contestants outside Barker's shop.

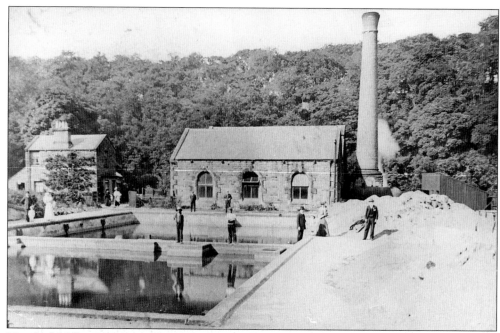

Humford Mill in its original state as a water pumping station and filter beds. In later years hundreds of Bedlingtonshire folks relaxed here in what was Humford Open Air Swimming Pool.

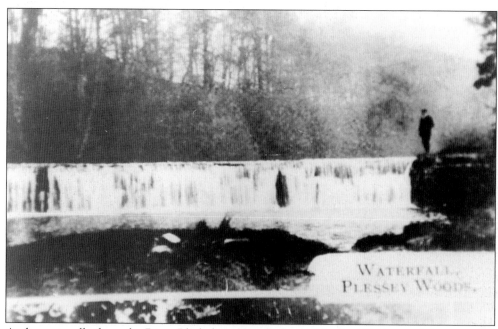

A pleasant walk along the River Blyth from Humford, past Hartford Bridge, and then another few hundred yards, brings you to Plessey Woods. It is still a popular place all these years later.

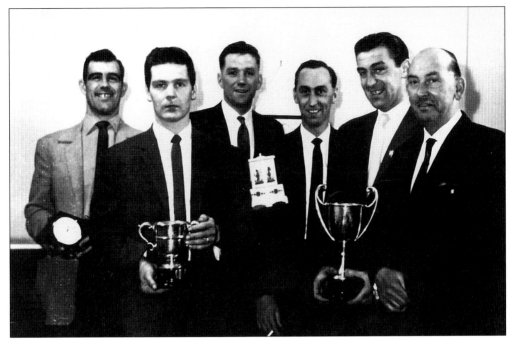

Indoor sports were always a prime form of relaxation in the past. Ken Jordan pictured here, third left, with the Bomarsund Social Club Darts Champions, was also a first class snooker and billiards player. Here, with the officials, are George Trewick (former Gateshead footballer), Eddie Mollon (Schultz), Ken Jordan and second right, Bill Forman.

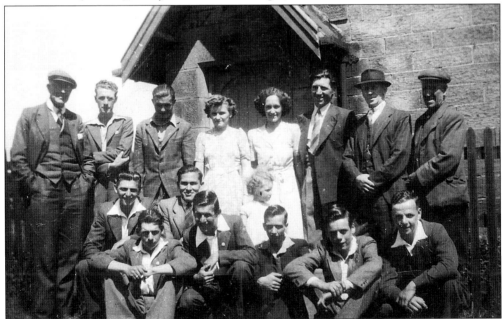

Whether your sport be indoor or outdoor, this 1946 Bedlington Young Farmers group would oblige. Included here are: Mr J. Taylor, W. Colville, M. Dodds, Ethel Abbs (secretary), Mrs Pattison, J. Pattison Jnr, Jack Elliott, Hylton Taylor (chairman), J. Straughan, W. Straughan, Tommy Hepple, G. Straughan, R. Smith.

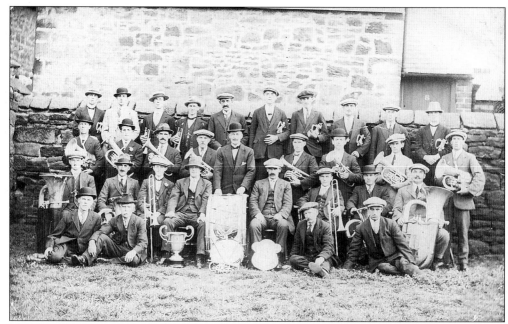

Most local collieries had a band and most were very successful. Barrington Colliery had a great tradition over many years and this is their band from around the period of the First World War.

Gardening and the complete use of allotments has always been a miner's trait. This is the house at Willowbridge, Choppington that Barrington headmaster Ben Berkley moved to in 1905. As the photograph shows, Berkley needed to be, and was, a keen gardener. He died here, at Willowbridge, in 1932.

118

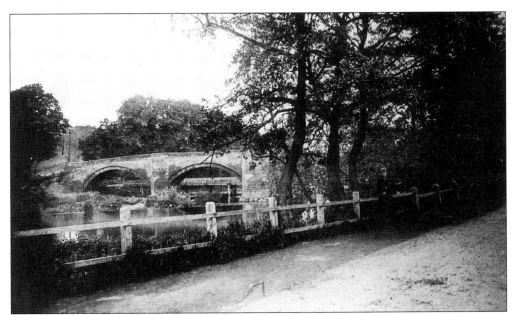

Just up the road from Willowbridge was the popular picnic spot of Sheepwash. This photograph shows the original stone bridge, two arches of which were swept away by abnormal flooding in December 1894.

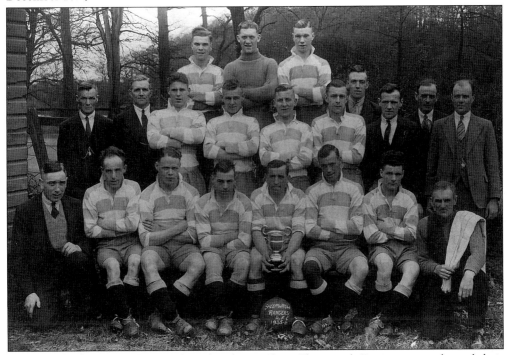

Across the road is the Sheepwash park. This is where Sheepwash Rangers once showed their footballing prowess. Back Row, left to right: J. Fairhurst, J. Tait, A. Fairhurst. Middle row: G. Hood, T. Young, G. Beal, W. Patterson, Mr Wilkin, J. Burns, Jim Tuck, G. Robson, R. Lister, Tom Jackson. Front row: Jack Logan, G. Alder, S. Richardson, N. Nelson, J. Lamb, T. Noble, A. Chapple, -?-. They were winners of the 1935-36 Nicholson Cup.

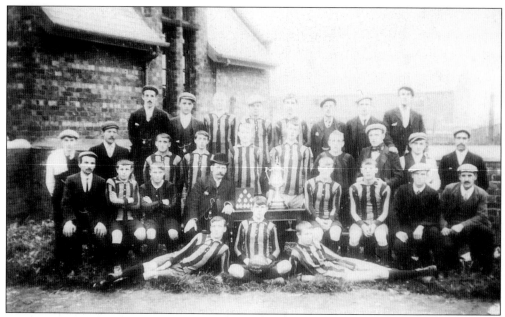

A Barrington football team, in the early days of the century, outside the institute, a building which is still there. This was a particularly good side and they named themselves 'The Villa' after Aston Villa's side, which had beaten Shankhouse Black Watch in an FA Cup match a few years before.

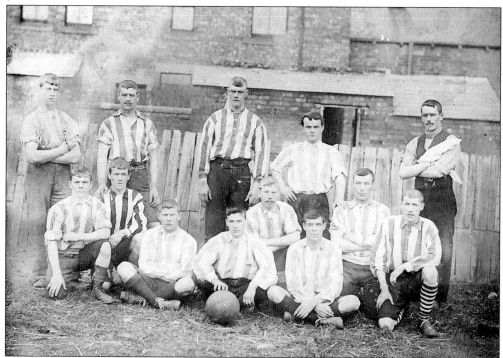

Seemingly not so sophisticated, but still a Barrington football team from around the First World War period. Third from the right is Harry Cracket who fought at the Somme and lived to tell the tale.

Football could be played for fun as well as for trophies, as these 1914 comic footballers proved. These were Barrington lads who were about to play Netherton in a charity match.

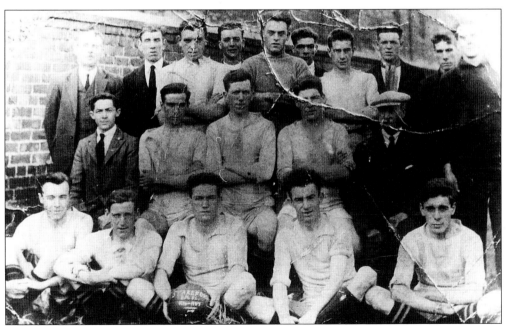

Nothing fancy about Stakeford Albion's team of 1926-27, pictured in West Terrace. Two of this side went off to play full time professional football. Back Row: J. Sanderson, Albert Cook, Fred Cook, J. Lightley, J. Tynemouth, Joe Rix, Fred Rix, Peter Yeouart, D. Rix, Bob Hostler. Middle Row: G. Percy, J. Scott, Joe Jordan, Ben Richardson, Joe Jordan Snr. Front row: -?-, G. Lowe, Sam Crosby, T. Burton, T. Percy.

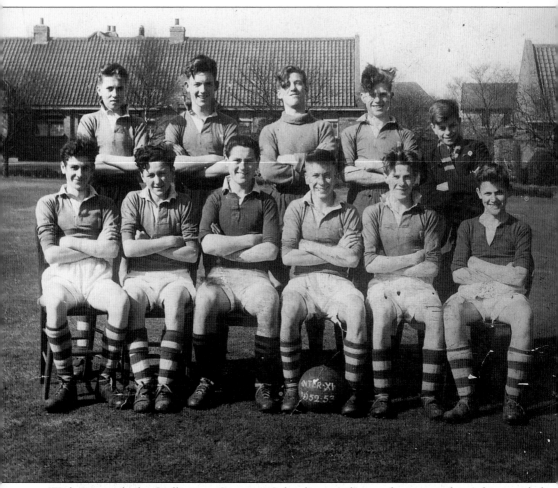

Without any doubt, Bedlington Grammar School's most famous former pupil is Ashington lad Sir Bobby Charlton, here with one of the school's most successful sides, the 1952-53 Intermediate XI. Coached by schoolmasters George Benson and Tom Hedderley, the team went through that season unbeaten until the final game, the Blake Cup Final at Blyth Spartans ground, Croft Park. The Bedlington lads were superconfident. After all they had beaten the opposition, Blyth Grammar, 4-2 only a few weeks before. With English international 'Chuck' Charlton in their ranks and County centre half Davie Bell, certain to be solid at the back, plus four other East Northumberland players, Blyth would have no chance. The crowd numbered 1,400 and a confident Bedlington side took the field only to be beaten 2-0 by a good Blyth side in which County winger Jimmy Pearson was outstanding. To say 'Chuck' Charlton was a fabulous player is a understatement. Club scouts followed the side's every game and Bobby was accompanied everywhere by Cissie, his mother. He was the smallest player in the team but had wonderful balance, control, speed, with a long stride, and the ability to hammer the ball from any angle and distance with either foot. Bobby left Bedlington Grammar at Easter 1953 to join Manchester United and Stretford Grammar School. Pictured here are, back row, left to right: Evan Martin, Bill Spratt, Bill Forster, David Bell, George Ferguson. Front row: Billy Lyall, Jimmy Bailey, Tom (Tucker) Robinson, Bobby Charlton (captain), Ken Earl, David Fenwick.

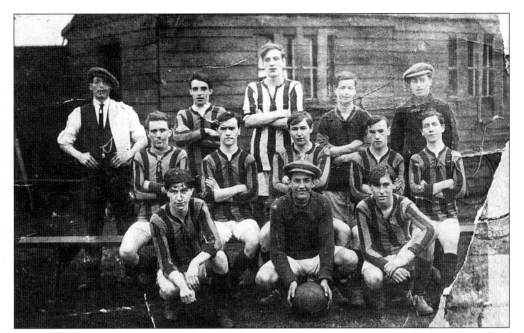

Football has been played in every available field in Bedlington. This is one of the town's earliest Junior sides, Bedlington Juniors, 1917-18. Back row: Welsh, Thompson, Smout, Binks, Thompson. Middle row: Shadforth, Hanson, Corner, Hanson, Goonan. Front: Ridley, Nelson, Thompson.

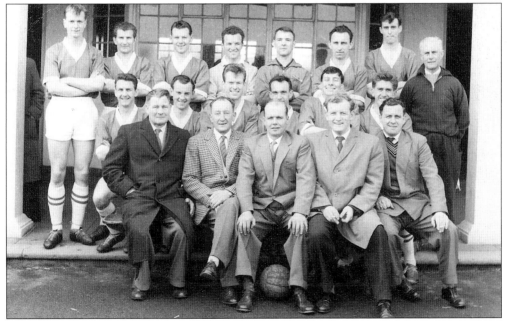

Bedlington Mechanics always had a strong squad in the post-war years and a side which played good open football. The team in 1959 were, back row: D. Richmond, S. Hamilton, R. Heslop, R. Routledge, H. Routledge, J. Patterson, C. Waldock. Middle Row: T. Bell, K. McIntyre, N. Clark, A. Anderson, D. Percy, P. Curtis, A. Anderson (trainer). Officials: G. Wilson, A. Jefferson, W. Pearson, W. Weatheritt, J. Mason.

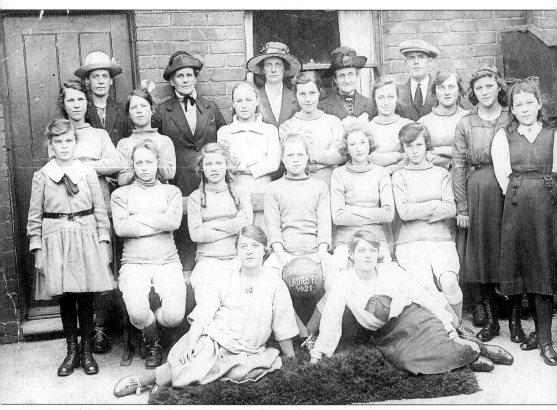

Men didn't have it all their own way on the football front. In the 1920s many of the pit villages had ladies' charity sides. This is Barrington's 1921 team. Holding the ball is Lillian Ritchie (later Lillian Graham, JP). Others include, Edie Scott, Ida Moody, Jenny Gutteridge, Mary Reed, Ena Taylor, Mary Kilgour, Gladys Saunders, Ella Tait, Jane Reed and Annie Graham. This team had a large amount of success, playing 22 games, winning all but one which was drawn, scoring 74 goals and conceding only 9 in the process. A male contemporary was heard to praise Lillian Ritchie, 'If she was a lad she'd be playing for the toon (Newcastle United).' Netherton, Choppington and Stakeford also had ladies' sides at this time.

BEDLINGTONSHIRE FREE PRESS

"The Terrier"

No. 296 Bedlington. August 18th, 1944. Circulation 7,500—Additional Copies 1d.

Terrier News Flashes

Barrington Comforts Fund.

By an omission on the Income side of the Balance Sheet for the above fund, published in our last issue, the total did not correspond with the amounts shown. This was caused by two donations being inadvertently missed :—West Sleekburn Miners £1, Bomarsund Miners 10/-.

H. Bell, Secretary.

Bedlingtonshire Voluntary Committee for the Blind.

This year's effort for this deserving cause exceeded all previous collections. The grand total was £108-3-0.

The very sincere thanks of the Committee are extended to the staffs and management of the Prince of Wales and Wallaw Cinemas, Bedlington, the Star Cinema, Choppington, to all collectors and anyone who helped in any way in this latest effort.

Mrs. D. Hughes, Hon. Secy.

Bedlington Music Successes.

At the July examinations of the Associated Board of Music, London, the following were successful—

Preliminary—

Marjorie Dale, Kathleen Rigby.

Primary (Grade 1)—

Alma Hale, Distinction, Iris Mavin, Credit, Hazel Straker.

Elementary (Grade 2)—

Mary Wilson, Distinction, Frank Hogg, Doreen Dobie.

Grade 4—

Joy Lockhart, Credit.

Pupils of (Mrs.) Ada Johnson, 4, East Riggs, Bedlington.

New Councillor for Bedlington.

At the Monthly Meeting of the Council last week, Mr. Harry Prime was elected to the vacancy caused through the death of Coun. Wm. Straker.

Councillor Prime is a prominent official of the local Miners' Association.

MILLNE for Cycle Accessories

Cycle Mudguards

From **2/-** per pair.

All Popular Patterns in stock.

Dunlop Cycle Tyre

All sizes in stock from 5/6.

Junior Sizes from 3/11. Tubes from 1/11.

You'll get the Size YOU want at Millne's.

Cycle Pedals only 3/9 pair.

Trouser Bands

From 3d. per pair.

JAMES H. MILLNE
Cycle Manufacturer, BEDLINGTON. Phone 3257.

Cycles Cleaned and Serviced : 4/-.
Replacement Parts fitted. : Complete Cycle Service.

WM. JACKSON, Goods Station Road, Bedlington Station.

(Behind J. S. Dunn's Butchers Shop).

The free paper is thought of as an innovation of recent years. Yet Bedlingtonshire Free Press was going sixty years ago.

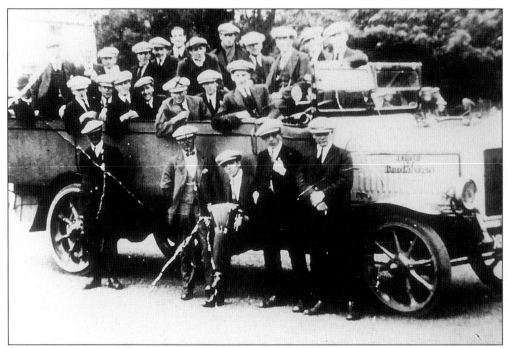

The solid wheeled charabanc didn't deter these Bedlington men, pictured before setting off on a day trip. Music was provided by the squeeze box player, seated at the front.

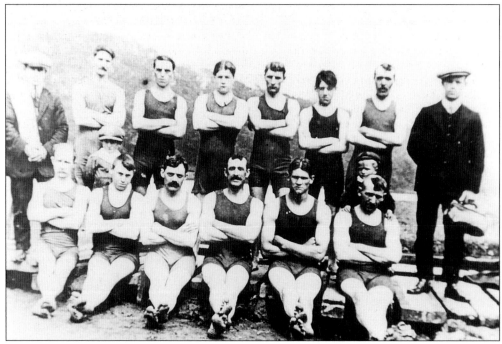

Hardy lads these, on the banks of the Wansbeck, c. 1912. They were members of the Stakeford Swimming and Rowing Club.

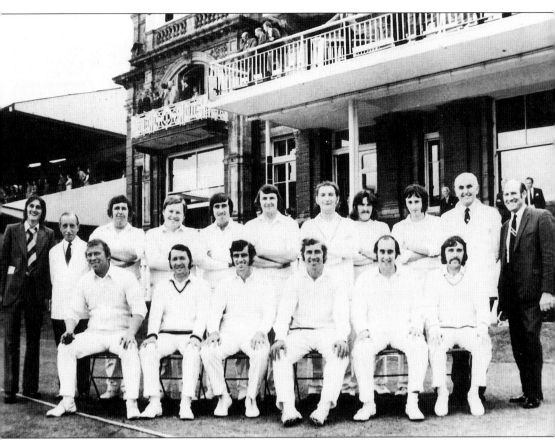

One of the greatest sporting achievements in the area's history was the winning of the Haig National Village Cricket Championship by Bomarsund Welfare in 1974. The local lads beat Collingham of Nottinghamshire by 3 wickets with 2 overs remaining. This was the culmination of a Summers Competition entered by almost 800 village sides and played at Edgbaston after a 'washout' at Lords. Bomar played six out of their eight ties prior to the final away from home and completely dismissed all their opponents. Only thirteen players were used throughout the series and no team scored more than 126 runs against them. This was a truly exceptional side. Back row: Steve Williams, umpire, Brian Thain, Keith Marshall, David Trewick, Jackie Herron, Tommy Burton, Tony Locke-Smith, John Haig, Umpire, Tom Bell. Front row: Dore Dreyer, Eric Appleby, Alan Trewick, Bob Trewick, Ian Richardson and Howard Halley.

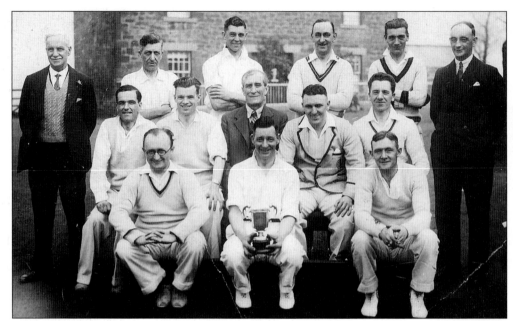

There has been a cricket club in Bedlington for over 100 years. Old church magazines of the early 1890s tell of games near the church and at Hartford Hall. This is a trophy winning side from around 1938. Back Row: R. Binks, W. Bussey, E. Wood, G. West. Middle row: W. Straker, R. Moffat, T. Griffiths, P. Marr. Front row: W. Thompson, J. Binks, -?-. Officials: W. Gray, A. Watson, J. Urpeth.

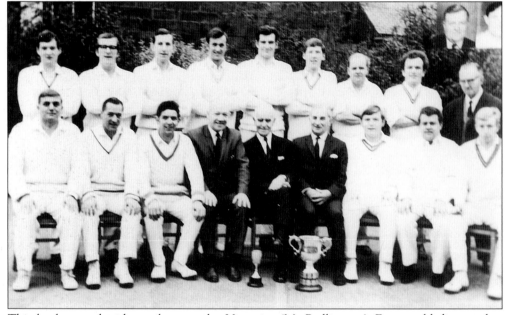

This book started with a tribute to the Victorian 'Mr Bedlington'. Few would dispute that honour in the twentieth century should go to Dr John Brown, in the centre of the front row. He spent over seventy years in the town and at one time it was said he brought more than half its population into the world. Dr Brown loved his cricket and was president of Bedlington Cricket Club. He died in 1996 in his ninety-fourth year.